Artists'
Questions
Answered
Oil Painting

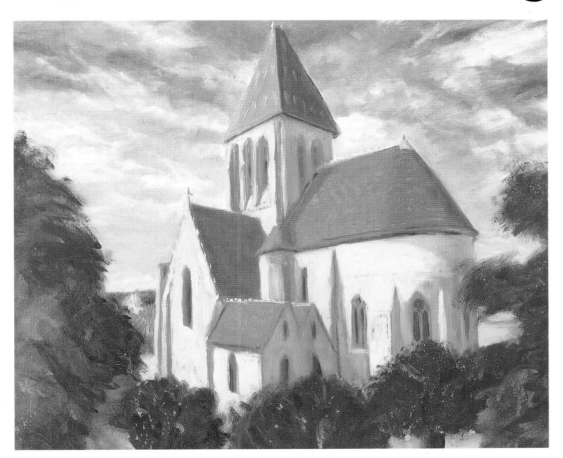

ROSALIND CUTHBERT

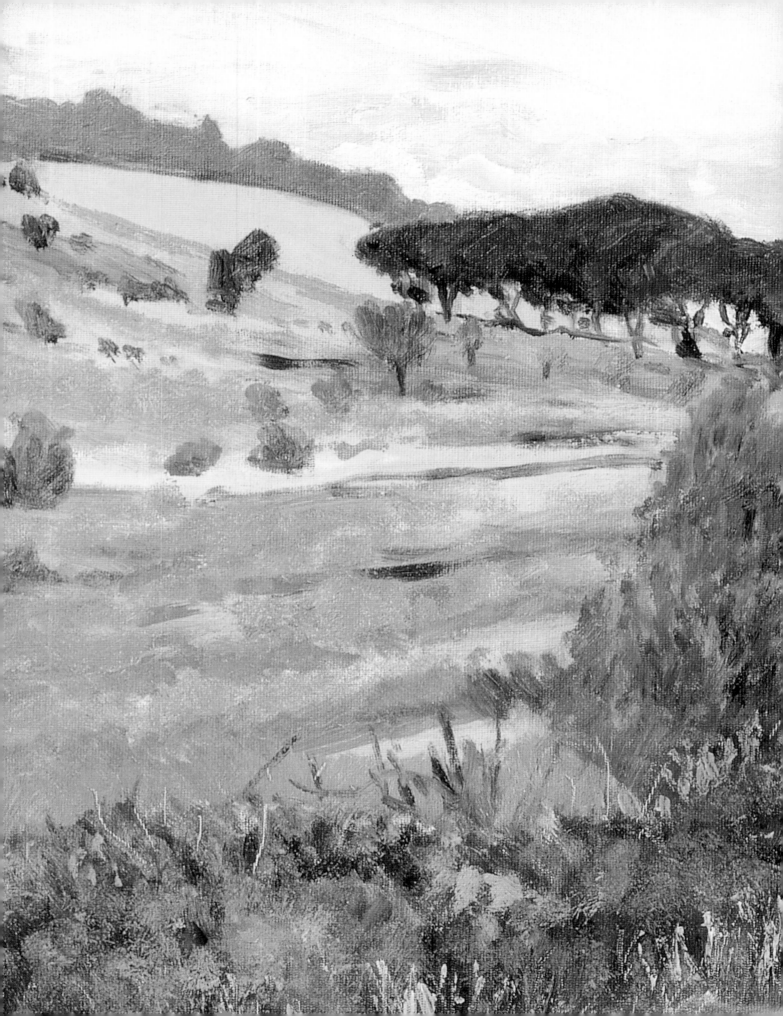

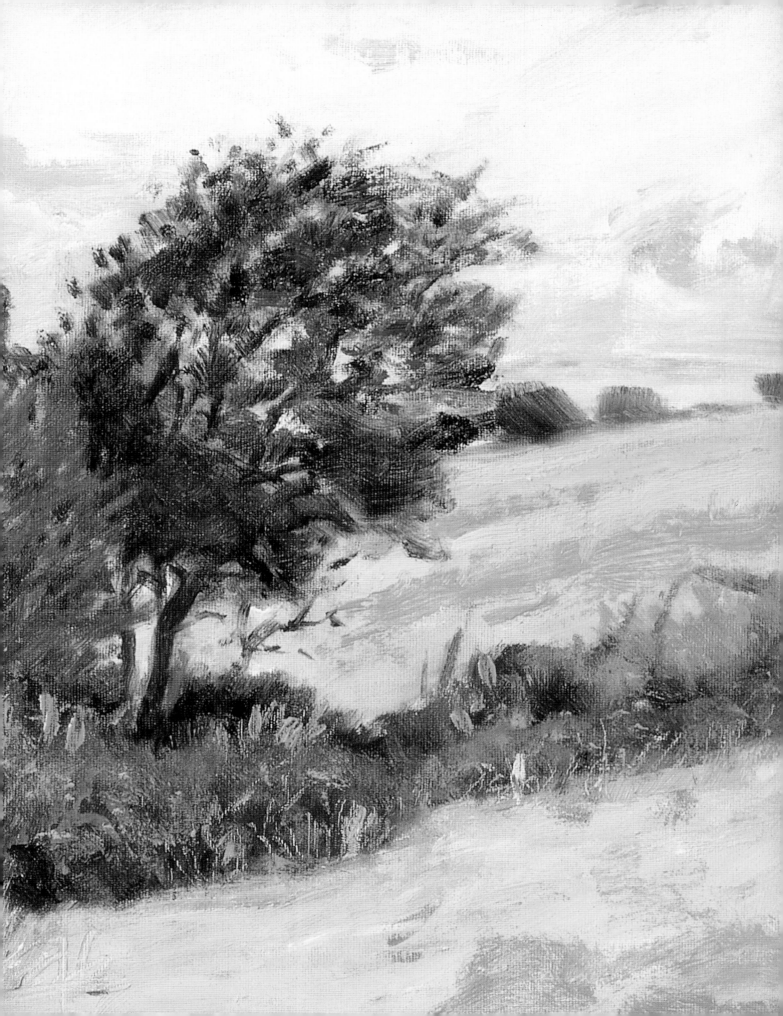

A QUINTET BOOK

Published by Walter Foster Publishing, Inc.
23062 La Cadena Drive,
Laguna Hills, CA 92653
www.walterfoster.com

ISBN 1-56010-807-X

This book was designed and produced by
Quintet Publishing Limited
6 Blundell Street
London N7 9BH

AQAO

Project Editor: Catherine Osborne
Designer: Steve West
Photographer: Jeremy Thomas
Creative Director: Richard Dewing
Associate Publisher: Laura Price
Publisher: Oliver Salzmann

Manufactured in Singapore by Universal Graphics Pte Ltd
Printed in China by Midas Printing International Limited

Contents

Introduction **6**

Key terms **8**

Chapter 1 Basic technique information **10**

Chapter 2 Understanding and mixing color **26**

Chapter 3 Composing and painting still life **46**

Chapter 4 Developing landscapes and townscapes **74**

Chapter 5 Depicting water **100**

Chapter 6 Painting figures **120**

Index **143**

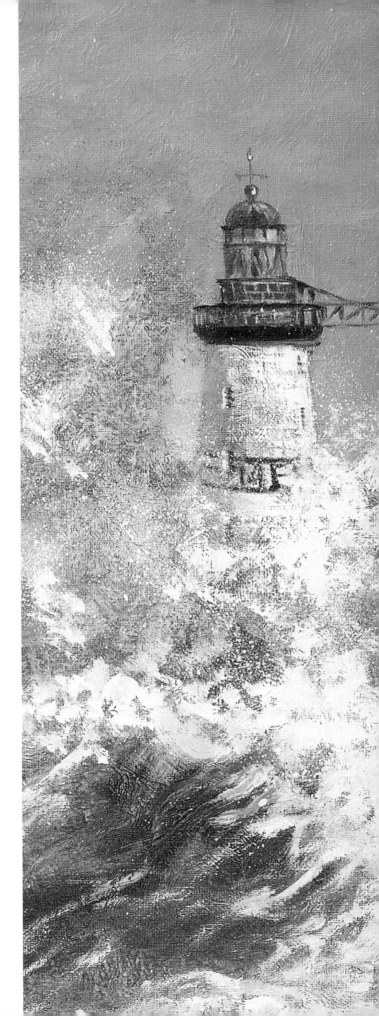

Introduction

People have made paintings as far back as we can peer into our history, from whatever materials were at hand. The first pigments were ground rocks, carbon, vegetable, and animal dyes. Then, these substances were used dry, smeared with fingers; or bound with water or animal glues. We use many of the same pigments today, although they have been added to—and also sometimes replaced—by new discoveries. More recently, new colors have been invented in laboratories, such as phthalocyanine and indanthrene colors.

Oil paint is said to have been invented by the painter Jan van Eyck in the Netherlands in the fifthteenth century. His famous painting *The Arnolfini Marriage* (1434) demonstrates his mastery on many levels. The fact that the picture has lasted so well and still glows with brilliant freshness today proves the durable qualities of the medium in the hands of one who knows how to use it. These qualities of richness and durability, along with its versatility, are the reasons its popularity is ensured.

Artists as diverse as Titian, Monet, and Picasso have used oil paint. Abstract painters and Pop artists, Expressionists, and Photorealists have used it, each movement renewing the possibilities of this wonderful medium. Contemporary artists such as Lucian Freud, Wayne Thiebaud, and Frank Auerbach also all use oil, each in a dramatically different way. The possibilities for expression seem endless.

The story of oil painting is long and grand, but this book is not intended to be a history of the medium. Rather, its purpose is to illuminate some basic principles and procedures so that you can develop a technically sound use of the medium, to give advice about equipment, and to make suggestions about picture making. Oil paint has a reputation for being a difficult medium to master; this book hopes to show you that there is no need to feel daunted. It will help you to paint with the confident enjoyment that comes with getting to know your medium and experiencing a growing awareness of the visual world.

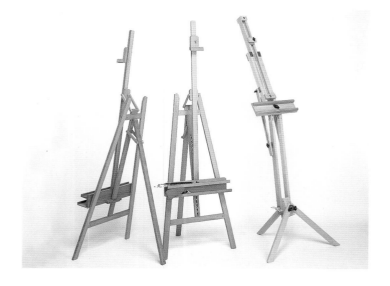

EASELS
Easels range from heavy radial easels, which are used indoors, to light portable easels, which are ideal for those who enjoy painting outside.

BOARDS AND TOOLS
1. Stretcher bars, wedges, and a stretched canvas
2. Painting boards
3. Palette and painting knives

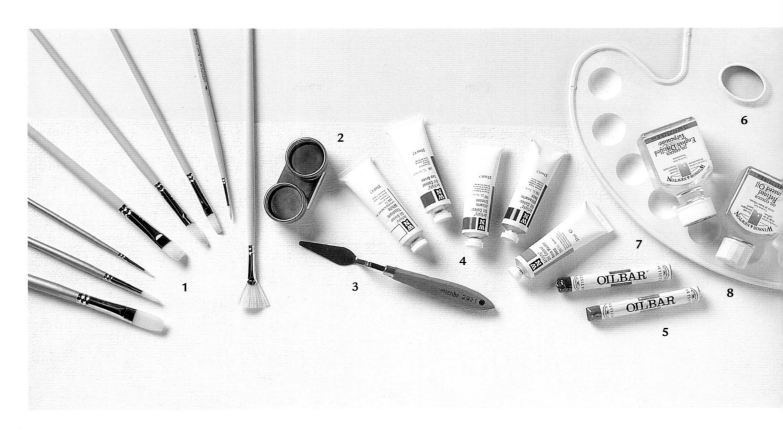

PAINTING EQUIPMENT

1 Brushes
2 Palette cups
3 Palette knife
4 Tubes of oil paint

5 Oil sticks
6 Palette
7 Distilled turpentine
8 Refined linseed oil

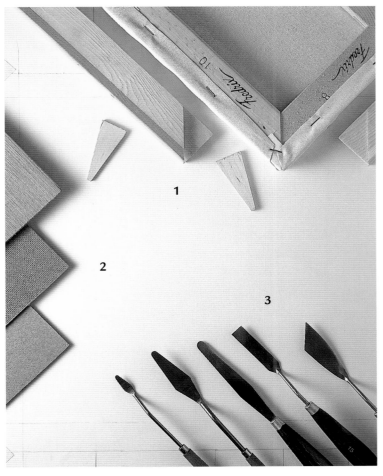

Key terms

Atmospheric (or aerial perspective—How the atmosphere affects the perception of distance, making distant colors cooler (bluer) and reducing contrasts.

Alla prima—Italian, meaning "first time": when a painting is completed with only one layer of paint applied.

Complementary colors—Colors that lie opposite one another on the color wheel. Each secondary color is made of two primaries—the third primary is the complementary.

Composition—The arrangement of the subject matter in a way that is harmonious and pleasing to the eye.

Fat—Possessing a high proportion of oil to pigment.

Filbert—A brush, shaped like a hazelnut, that tapers like a flattened cone.

Fixative—Made from synthetic resin; can be used to seal pastel or charcoal drawing. Fixative can be toxic and should be used outdoors.

Foreshortening—A perspective term used to describe an object appearing to diminish in size as it recedes from the viewer.

Form—The appearance of the subject matter—its line, contour, and three dimensionality.

Glaze—Transparent film of paint over an area of color that has already dried.

Gradation—A gradual, smooth change from dark to light or from one color to another.

Ground—A layer of color, possibly with a texture, used as a base on top of which the rest of the colors are applied.

Highlight—The area on any surface that reflects the most light.

Horizon line—An imaginary line at the same level as your eyes. If you are on a flat plain, the the horizon will be the same as the skyline. If you are looking at hills the horizon will be lower than the skyline.

Hue—The pure color, as distinct from its lightness or darkness.

Impasto—Paint applied thickly, so that the brush or palette knife marks are visible.

Lean—Paint containing little oil in relation to pigment.

Linear perspective—A technique of drawing or painting used to create a sense of depth and three

dimensionality. Most simply, the parallel lines of buildings and other objects in a picture converge to a point making them appear to extend back into space.

Luminosity—The effect of light appearing to come from a surface.

Mahl stick—A stick with a padded or ball-shaped end, used as a rest for your arm to keep your hand steady when painting.

Medium—The material or technique used by an artist to produce a work of art.

Negative space—The space around an object, which can be used as an entity in composition.

One-point perspective—A form of linear perspective in which all lines appear to meet at a single point on the horizon.

Opaque—Something that cannot be seen through; the opposite of transparent.

Palette—A flat surface on which to mix paints.

Perspective—The graphical representation of distance or three dimensions.

Picture plane—The plane occupied by the surface of the picture. When there is any

illusion of depth in the picture, the picture plane is similar to a plate of glass behind which pictorial elements are arranged.

Primary colors—The colors that cannot be mixed from any other colors; yellow, red, and blue.

Proportion—A principle of design referring to the size relationships of elements to the whole and to each other.

Resists—Materials that protect a surface from paint in order to maintain paint-free areas of paper. Paper, masking tape, and masking fluid are all resists.

Sable—Bristle brush made of soft hairs that come from a variety of animals, particularly suited to soft applications of color.

Scumbling—Dragging dry, opaque paint across a layer of underpainting to give a broken color effect.

Secondary colors—Colors made from mixing two primary colors, for example, orange (red and yellow), green (blue and yellow), and purple (red and blue).

Sgraffito—Lines produced by scratching through one surface of paint to reveal the color underneath.

Shading—The application of light and dark values that gives a three-dimensional appearance to a two-dimensional drawing or painting.

Sketch—A quick freehand drawing or painting.

Spattering—A method of spraying droplets of paint over a painting with either an old toothbrush or a flat brush.

Sponging—Applying paint with a sponge to produce a textured surface.

Stippling—A method of shading that uses dots instead of lines.

Stretcher bars—A wooden frame on which canvas is stretched.

Support—The paper, board, or canvas on which the drawing or painting is made.

Tertiary colors—Colors that contain all three primary colors. Brown, khaki, and slate are all tertiary colors mixed from varying combinations of the three primaries.

Texture—An element of art that refers to the surface quality or "feel" of an object— its smoothness, roughness, softness, etc.

Tint—A color to which white or water has been added to dilute the hue. For example, white added to blue makes a lighter blue tint.

Tone—Without reference to color value, the degree of lightness or darkness in an area or object.

Tonking—A technique in which paper is pressed onto a painting to remove excess paint and reveal the underdrawing.

Underdrawing—A sketch of the composition with pencil, charcoal, or paint that suggests tonal differences.

Vanishing point—The point on the imaginary horizontal line representing eye level where extended lines from linear perspective meet.

Viewfinder—L-shaped pieces of cardboard that are placed together to form a rectangular shape, used by artists to frame a composition.

Warping (buckling)—The wrinkling that occurs to lightweight papers after wetting. The heavier the paper, the less warping occurs.

Wet-into-wet—Technique in which wet paint is worked into a still-wet layer of paint.

1
Basic technique information

Art supply stores offer a huge choice of equipment for oil painting, from paints, and brushes to a host of other specialty tools. To begin, you really don't need to spend a lot of money or buy every available piece of equipment. An easel is useful, but you can just as easily sit at a table with your work supported on a slanted board. A few tubes of paint, a basic palette, three or four brushes, and a bottle of turpentine, along with something to paint on, are all you need to get you started. You can paint in oil on a canvas-covered painting board from the art store, an oil painting sketchbook with primed pages, or even a piece of cardboard primed with house paint, so there is no need to buy expensive canvases at the outset.

It is important to give as much importance to drawing as to painting. Keep a sketchbook, and use it often. You will be more capable—and therefore more confident—with a brush in your hand if you have some experience in setting down your observations with a pencil.

Do not rush into oil painting expecting to create masterpieces. Take time to get used to the paint and brushes. Be open-minded, and try different ways of doing things. Explore the different effects and marks that can be created with flat brushes, hog brushes, filberts, and riggers. And don't just limit yourself to brushes. You can create interesting textures with a sponge, toothbrush, and your fingers.

The main thing to remember when you start painting with oil is not to panic if you make a mistake. This doesn't mean that you have to start your painting all over again. There are many ways to correct a mistake, including scraping and wiping off unwanted paint, overpainting, and tonking (see page 24). As you master the media, however, you will also learn to recognize that many "mistakes" can in fact be incorporated into interesting paintings. Keep your early paintings for reference. Even mistakes can make useful reminders of what can go wrong and how to remedy or avoid it.

There so many types of brush, what do they do? Should I buy them all?

There are a bewildering number of different types, shapes, and sizes of brush in art supply stores. The main materials used for the brush hairs are hog (or bristle), sable, and nylon. Hog bristle brushes are stiff and designed to leave brush marks in the paint, whereas nylon or sable brushes are generally used for finer, more delicate work. As a simple guide, wider brushes hold more paint and make thicker, bolder marks; narrow brushes hold less paint and make delicate marks.

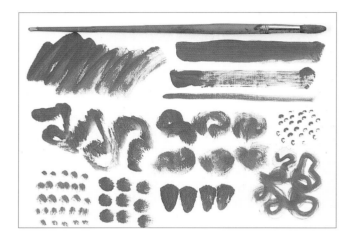

A round hog is a great all-purpose brush. Hog brushes in general are good for looser styles of painting, but the tip can also make relatively fine marks for painting details. The more pressure you apply, the wider the mark. Use a large hog brush for blocking in large areas of color.

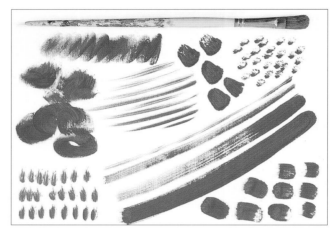

Filbert brushes are flat with a rounded end. They are named for their outline, which is similar to that of a hazelnut. Hold the brush flat to produce wide strokes and on its side for narrow ones. Filberts are also available with short bristles—these hold less paint and are better for short, accurate brush work.

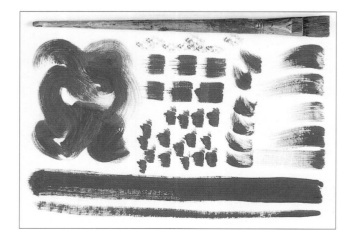

Flat-ended brushes are available with long or short bristles and produce a characteristic squared-off mark, very different from the round and filbert brushes. These brushes work well if you need to block in areas of color. They are also good for creating texture, especially for things like wood and brickwork. Use the end or side of the brush for narrow lines or marks.

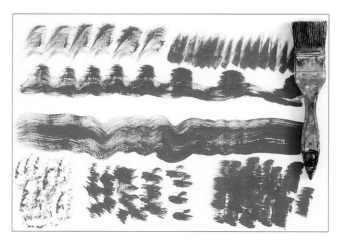

Decorator's brushes are very useful for priming, laying down large areas of color very quickly, and creating a wide range of brush marks in a painting. Don't buy cheap brushes; they may shed and leave bristles in the paint.

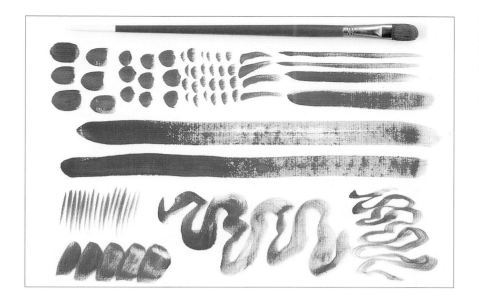

Nylon brushes make softer marks than their hog counterparts do, and they are ideal for use with thinned paint because they leave few brush marks in the paint. They are good for glazing and blending, and for fine detail work.

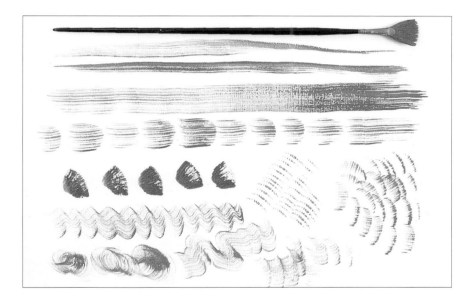

A fan brush is not a basic requirement, but it can be fun to use. It is ideal for blending and for creating textures, such as those of hair and fur.

ARTIST'S NOTE

Always clean your brushes after use. Wash them in mineral spirits: then rub them gently on a bar of soap and work up a lather in the palm of your hand. Rinse them thoroughly and allow them to dry naturally. It is also important to clean your brush between each new color. Have a jar of mineral spirits nearby while you paint. As you finish with a color, rinse your brush in the spirits and wipe it clean on a soft rag before applying the new color. This will ensure your colors do not become muddied.

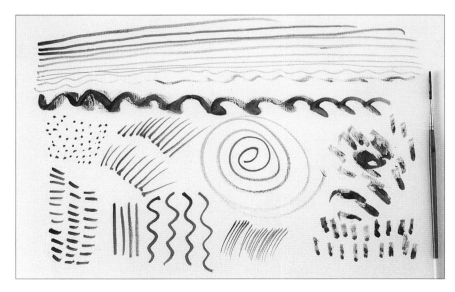

Like the fan, the rigger brush is not a basic requirement. It was designed to paint the rigging on paintings of sailing ships, hence its name. Its hairs are very long so it can hold plenty of paint, and its tip is flat, so the lines it makes are consistently the same width. These brushes are great for painting long, thin, continuous lines.

There so many types of brush, what do they do? Should I buy them all? **13**

Store-bought canvases are expensive. How do I stretch my own?

Stretching your own canvas needs some investment and practice, but it offers more freedom over your size of painting and financial savings in the long term. To stretch a canvas you will need two pairs of stretcher bars for the frame and a pair of pliers to help you create enough tension on the material.

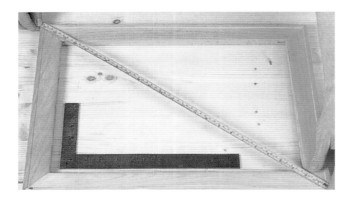

1 Tap the stretcher bars together to make a frame, and check its squareness with a large L-square or by comparing the diagonals with a tape measure.

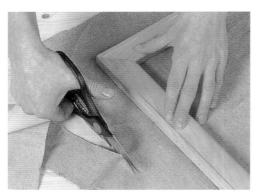

2 Lay the stretcher frame down on the canvas, allowing an overlap of about 3 inches (7.5 cm) all around.

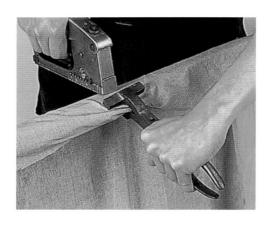

3 Make sure that the warp and weave threads of the canvas are parallel with the edges of the frame. Pull the canvas taut and staple it to the center of one of the long stretcher bars; then repeat the process on the other side.

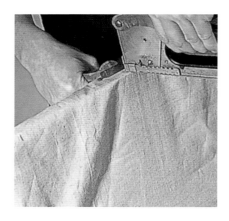

4 Do the same with the shorter sides, taking care to pull the canvas taut with the second pair of opposing staples. This prevents the canvas from being stretched unevenly.

5 Return to the first long side and place a staple 1½-2 inches (4-5 cm) to the right and left of the first staple. Do the same to the remaining sides. Continue working outward from the center toward the corners, pulling the canvas taut as you go.

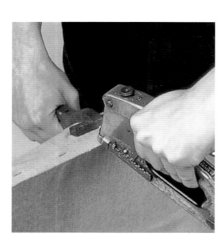

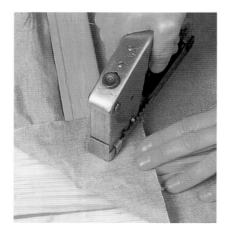

6 Fold the canvas around the corners and staple it to the back.

When should I thin oil paints, and by how much?

Always observe the golden rule of oil painting—work from "lean to fat." As oil paint dries, it is very absorbent and will draw oil away from any layers painted on top, making your painting look dull and lifeless. If you dilute the paint, it dries more quickly and prevents this from happening. As you progress to each paint layer, it should contain less dilutent, so that the thickness of the paint increases. Only when you get to the very final layers can you start to use paint straight from the tube.

The simplest way to dilute oil paint is with turpentine. Some beginners use mineral spirits, but that won't produce a beautiful or durable paint surface. For small amounts of paint, squeeze a little paint onto your palette, and mix in the turpentine with a brush until you have the desired consistency. Add a little turpentine at a time—it is much easier to thin paint than to thicken it again. Also make sure that you have a smooth consistency so that the paint goes on evenly. Turpentine dries the paint out, so in time it may crack or flake. To compensate for this, add a little linseed oil to the mix to produce a durable, elastic paint surface with a rich, glossy appearance. But add the oil sparingly; it can increase drying time by days or even weeks.

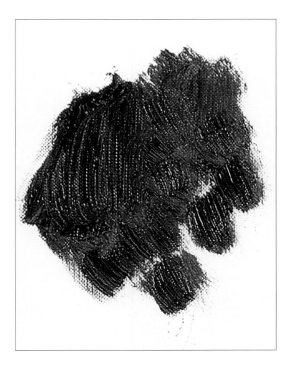

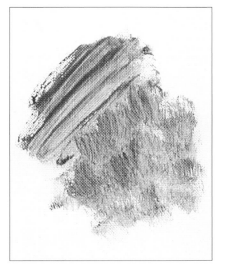

Thinned with alkyd (synthetic) painting medium, permanent mauve retains its color while appearing more transparent.

Thinned with pure turpentine, the paint consistency is much more liquid and the effect even more transparent.

Permanent mauve is a transparent pigment, used here straight from the tube. Transparent pigments can look very dark unless they are thinned down.

I get the same textures and effects time after time with brushes. Are there other tools I can paint with?

You can create many exciting and unexpected effects in paint with a variety of tools, adding to the range of marks you make with brushes. These techniques include scratching, spattering, sponging, and finger painting.

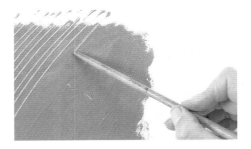

Apply a layer of paint over an already-dry ground. Then scratch into the wet paint surface with the handle of your paintbrush, a painting knife, or any other pointed implement to create uniform, sharp lines that reveal the colored ground beneath. This technique is known as *sgraffito* and is a great technique for painting grasses.

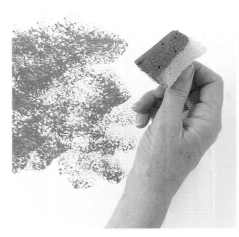

Create a broken paint texture with a piece of sponge. Thin the paint with turpentine and apply the sponge to your paper. This kind of texture has many uses, such as adding interest to an expanse of foliage, to the walls of a building, or even to a cloudy sky.

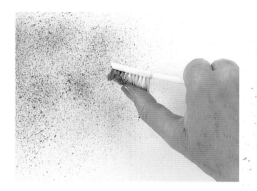

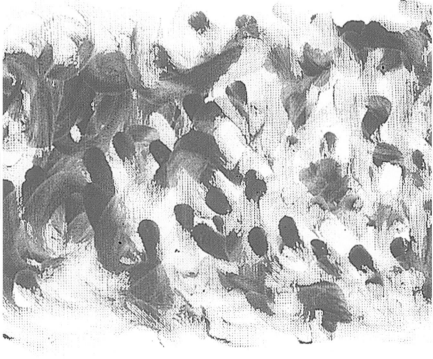

A toothbrush is great for spattering a fine spray of paint onto the picture. Thin the paint with turpentine to a very runny consistency. Add a little linseed oil or painting medium, dip your brush into the mixture, and flick the paint onto your paint surface. Make sure your painting is flat on the table so that the paint does not run. Spattered paint gives a dramatic impact to moving subjects such as sea spray and storm clouds or added subtlety to misty scenes.

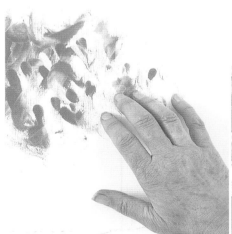

For smooth, sculptural effects, apply the paint with your fingers. Use your fingers to blend colors and soften sharp edges. Swirl or drag the paint depending on the effect you want to create. Sometimes it is good to be drastic with your picture surface, such as when it looks too tidy, predictable, or over-controlled.

What are some basic rules for drawing preliminary sketches?

Your sketch is the map or plan of your painting. Concentrate on the major shapes, forms, and the relationship among objects, and draw in the main outlines of your composition. At first, you will probably want to use something that you can erase if you make a mistake, so draw your outlines using a soft pencil or a stick of charcoal. If you draw in pencil, avoid the tendency to get carried away with too much detail. Do not worry if you make a mistake; you will cover it later with the paint. As you become more confident, sketch your subject with a brush to loosen your sketches and to develop a smooth transition from drawing to painting.

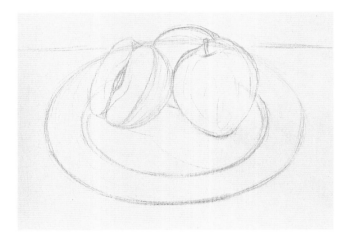

For a pencil sketch be sure to use a soft pencil—a hard pencil will indent the picture surface and be difficult to erase. Draw in the outline only; do not fill in any areas of shade or tone but concentrate instead on the shapes. Too much graphite will dirty your colors, so, when you are happy with the drawing, gently erase the whole drawing so that you can just see a faint outline.

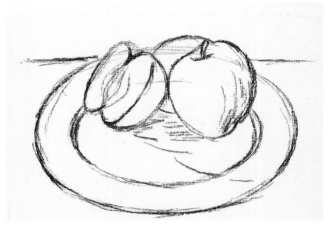

Charcoal is a much broader medium than pencil and will encourage you to draw simply and freely. Sketch the outlines roughly and then spray it with a fixative, so the charcoal won't smudge into your paint later. Alternatively, you can dust your sketch with a piece of cotton wool so that only a ghostly impression is left behind.

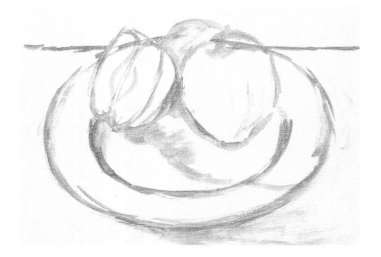

Sketching with paint can be daunting, but it actually makes it easier to apply paint later on. Dilute your paint with turpentine to speed up the drying time. If you make a mistake, just wipe off the drawing with a rag dipped in turpentine.

What is impasto, and when should I use it?

Impasto is the term for using paint that has the consistency of paste and is applied generously, either with a bristle brush or with a knife. The paint stands off the canvas in thick brush marks, ridges, or slabs, and can be worked to create a densely textured surface. You will use a great deal of paint, so mix your colors first with impasto medium—a substance available at art supply stores—designed to extend the paint without reducing the color intensity. Then apply the color in thick layers. Such thick paint can take at least a year to dry, so impasto work should be done quickly in one sitting and not overpainted. If you make a mistake, scrape the paint away with a knife and start again.

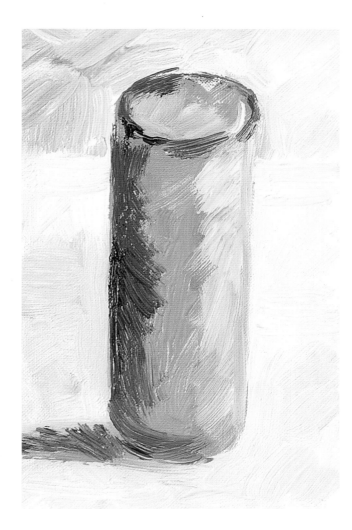

In this example, the paint was applied with a hog bristle brush. The brush marks are clearly visible in the rich, textured surface.

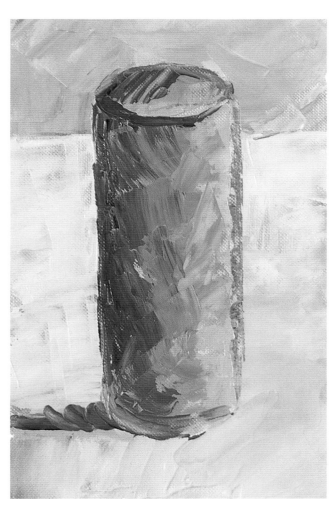

Here, the same mix of paint and medium was applied with a painting knife. The knife imparts a lively, uneven texture to the paint, ideal for painting rough textures.

I often overwork my paintings and have heard that painting *alla prima* might help. What is *alla prima*?

Alla prima describes a painting completed in one sitting. It is a simple and direct approach to oil painting, and it is very popular with amateur artists. *Alla prima* encourages a straightforward and even energetic painting style. It can result in lively color and brushwork, and it is commonly used by artists when working out of doors. Many of our best-loved artists used this approach, including Van Gogh, Monet, and Pissarro. You can paint *alla prima* on a white primed surface or on a drawing or underpainting that has been allowed to dry. Although colors can be mixed on the palette, they can also be mixed and blended together on the canvas itself. Apply the colors to the canvas side by side and blend them wet-into-wet.

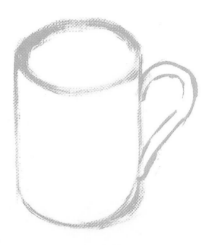

1 Paint the contours of the mug with a light-colored paint thinned with turpentine. When you draw with a brush rather than pencil or charcoal, it is easier to move from the "drawing" stage to the "painting" stage, as you do not have to change media.

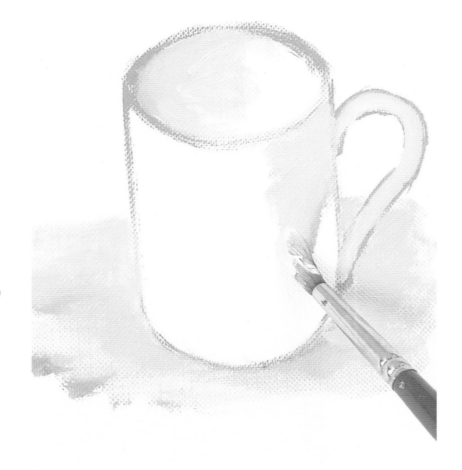

2 Observe where the light falls on the mug, and block in the paler areas with a mix of your sketching color and titanium white.

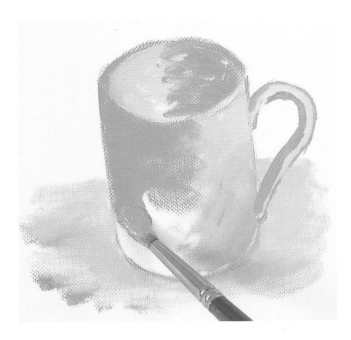

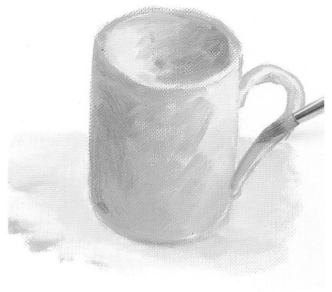

3 Continue to block in color using a brighter mixture of colors. Roughly blend the color into the lighter mix applied earlier. Vary the tone so that it gets lighter as you move toward the light side of the mug; you do not want sharp contrasts.

4 Add some ultramarine to the mix, and develop the shadows. Apply the color roughly to give the mug some texture, but blend it gently into the colors applied earlier to create a gradual tonal change.

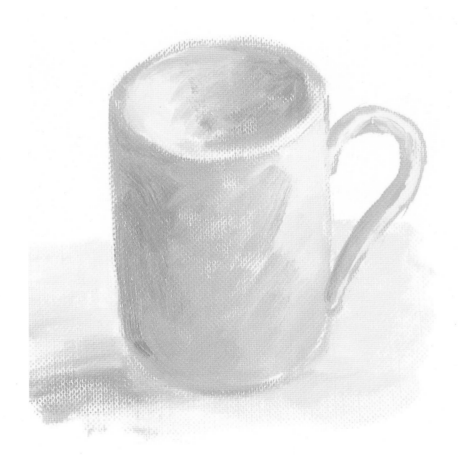

5 The contour drawing disappears under the layers of paint. Working the paint wet-into-wet, and using the *alla prima* method have given the mug a convincing three-dimensional form in a short amount of time.

I often overwork my paintings and have heard that painting *alla prima* might help. What is *alla prima*?

What are the best ways to make corrections in oil?

Corrections can be made very easily with oil, so don't panic if you make a mistake. If you apply a small amount of the wrong color, it can be removed with a cotton swab or a small, clean brush. Larger mistakes can be scraped back with a painting knife, then wiped clean with a little turpentine on a rag. Large or small areas of a picture can also be glazed over, once they are dry, to adjust a color or improve the color balance.

1 If you have applied the wrong color to your painting, simply scrape off the offending color with a knife. In this case, the yellow ochre is far too bright.

ARTIST'S NOTE

An artist using a painting knife will constantly scrape off and reapply paint until the desired effect is achieved. It's an exciting technique, but it's wise to restrict the number of colors you use until you have the feel of it, as the paint will quickly lose its freshness if overworked.

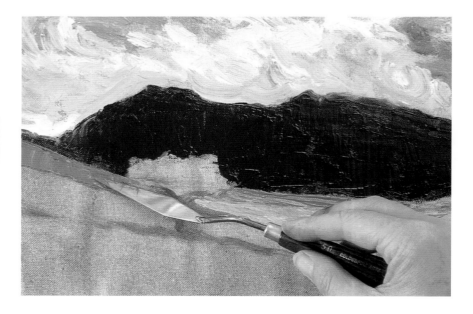

2 Remix the correct color and reapply with a palette knife or a brush. Here the color is made a shade darker using raw sienna.

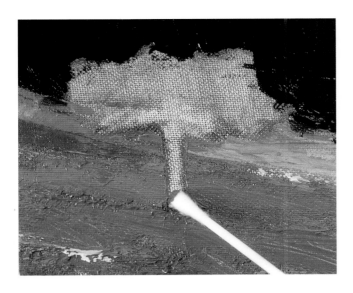

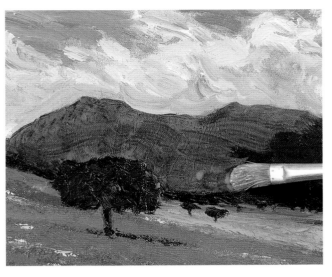

To remove small areas of paint, such as this tree, scrape away the unwanted color with a palette knife. Then clean the area with a cotton swab and turpentine and paint the correct color.

If you make an area of your painting too dark, like the hill in this landscape, let the paint dry and apply a lighter glaze of colors. In this case, a semi-opaque blue was applied to cool the whole area.

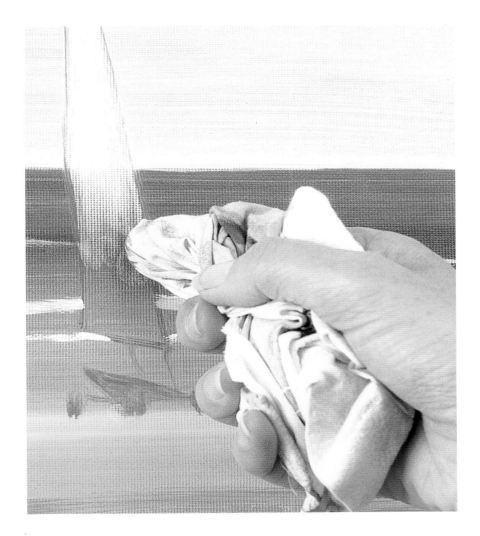

An alternative to scraping off paint with a knife is to dip a clean rag into some turpentine and gently rub away the unwanted color, taking care not to touch any other areas. Here, to achieve the continuation of the lines of the sky and sea, the paint was initially applied over the sail. Once the paint is removed, the sail is ready for its own color.

I often cover my sketch lines with paint before I have finished using them. Is there anything I can do if this happens?

Professor Tonks at the Slade School of Art in London developed a technique for removing large areas of excess or "wrong" paint from a painting, a techniques now known as "tonking." Press a sheet of newsprint onto the painting, then lift it off. The excess paint will come up with it and reveal the underdrawing. This also works if you apply the wrong color to a large area of your painting.

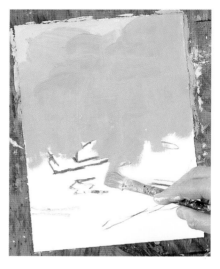

ARTIST'S NOTE
Once the paper has been placed over the area you want to tonk, you should rub it gently to ensure that the excess paint soaks into the paper. You can also use this technique to soften any hard edges.

1 To practice tonking, paint the outline sketch or underdrawing as you would for any painting.

2 Add a thick opaque layer of paint over the drawing so that it is entirely covered.

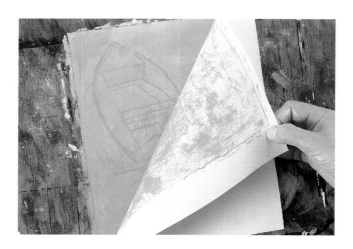

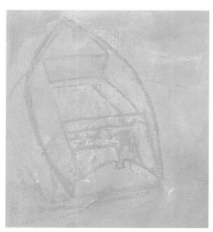

3 Lay a sheet of newsprint over the drawing and press it firmly onto it. Rub the back of the paper gently, then peel it back; much of the paint layer will lift with it.

4 The drawing is visible once more. This is a great way of removing paint where the drawing has been lost under too much color.

What are some simple rules of perspective?

When you paint on a flat, two-dimensional, surface, the challenge is to create an illusion of three-dimensional depth. The basics of linear perspective will help you make objects appear to recede convincingly. Imagine a cube. Unless you are looking straight on to one face, the edge of a face farthest away from you appears to be shorter than the edge nearest to you, and the horizontal lines appear to be converging as they recede from you. In all basic diagrams of perspective, there is a theoretical spot on the horizon line called the "vanishing point" to which all lines horizontal eventually extend. There can be an infinite number of vanishing points, but the basic rules of perspective involve one, two, and three points.

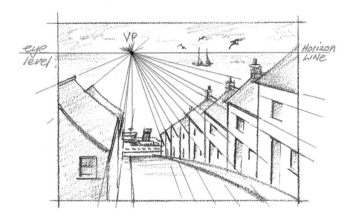

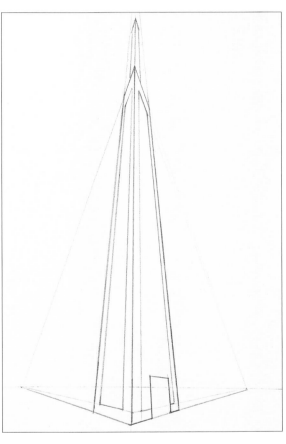

One-point perspective, high eye level
The position of your eye level will greatly affect your view of a scene. Your eye level directly corresponds to the horizon and the vanishing point is where all lines parallel to your line of vision will converge. In this example of one-point perspective, high eye level allows you to see the bottom of the street, the boat, and the sea.

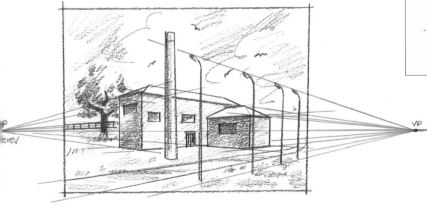

Two-point perspective
In this diagram, there are now two vanishing points because the building appears to be receding in two directions.

Three-point perspective
Tall things recede vertically as well as horizontally. In this diagram, the building is far higher than your eye level, so a new axis has been added—a vertical axis. Somewhere along this axis, the sides of the building have been projected with dotted lines to meet at a new vanishing point. Because the building is mostly above your eye level, its top edges recede downward toward the vanishing points on the horizontal axis.

2
Understanding and mixing color

Understanding color theory is fundamental to painting. You should have a firm understanding of primary, secondary, complementary, and tertiary colors, especially with regard to mixing. The three primaries are yellow, red, and blue, and these hues provide the key to mixing secondary and tertiary colors. Almost any color—except for black and white—can be made from these three primaries.

Your starter palette should be basic and should contain a warm and cool hue for each primary, for example, lemon yellow, cadmium yellow, cadmium red, alizarin crimson, cerulean blue, ultramarine blue, and titanium white. You will discover that a wide range of colors can be created from this simple selection as long as they are combined correctly. For example, many beginners make the mistake of adding black to make a color darker. In fact, this makes it appear dull and lifeless on the paper.

The term *hue* indicates the color value as distinct from its lightness or darkness. *Tone* is the quality of light and dark. For example, when a colored picture is reduced to shades of gray on a photocopier, we can see the tonal values clearly. Knowing the effects of tones and hues in oil is important, especially for layering colors and creating light and shade. Paul Cézanne stated that "light cannot be reproduced, but must be represented by something else, color": a sense of light is created by the juxtaposition of colors. Shade is also a mix of hues. You will very rarely find that the shadow cast by an object is pure black.

Oil paints come in both transparent and opaque pigments. Transparent colors can look almost black when applied straight from the tube and often need diluting with turpentine or a painting medium to reveal their brightness. To make a transparent paint opaque, simply add white. Transparent pigments make excellent glazes and can cool a painting down or add life to a painting that has become too dull. Learning how to apply glazes is essential when it comes to making the most of your oil paintings.

Colors can also be defined in terms of saturation. A fully saturated color is one used at full strength to obtain maximum intensity. *Desaturation*, on the other hand, describes diluting a paint to reduce its intensity. This chapter shows you when and how to dilute oil to achieve colors that are both delicate and powerful. It also gives you basic ground rules for working with color, allowing you to create visual harmony.

What are primary and secondary colors?

The three *primary* colors are red, yellow, and blue. They are called "primary" because they cannot be mixed from any other colors. Mixing red and yellow makes orange, yellow and blue make green, and red and blue make violet; these are the secondary colors. The color wheel is a convenient way of demonstrating this. It is based on the colors observable in the spectrum, which are placed into a circle so that the secondary colors are between their constituent primaries and each color is opposite its complementary (*see* page 29).

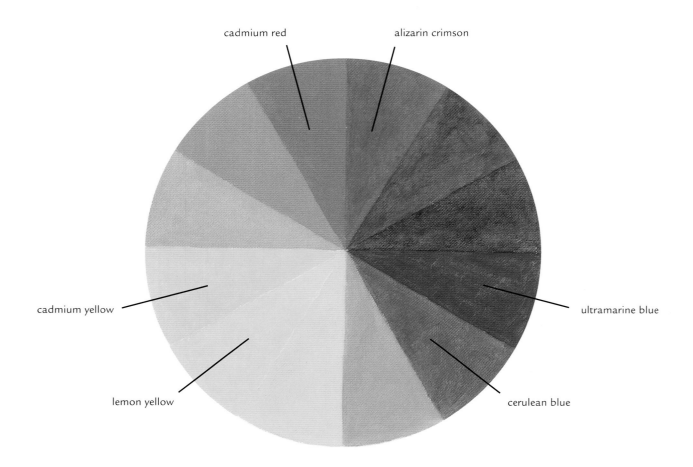

cadmium red

alizarin crimson

cadmium yellow

ultramarine blue

lemon yellow

cerulean blue

Unlike colored light, (the spectrum), the various red, yellow, and blue pigments are never pure, but always "tend toward" one another. For instance, cadmium yellow is a warm yellow that tends toward red, while lemon yellow is cool and tends toward blue. In this color wheel two different pigments for each primary color have been used—a warm and a cool (*see* page 31). Two possible secondary color mixes of adjacent pigments have also been shown, for instance between lemon yellow and cerulean blue there is a yellowish green and a bluish green.

What are complementary colors?

There are three pairs of *complementary* colors, each composed of one primary and one secondary color. This means that each pair contains a balance of all three primary colors, but in different combinations. The three pairs are red and green, orange and blue, and yellow and violet, and they are easy to spot on the color wheel (*see* page 28) because they are opposite one another. The colors in your tubes of paint are never pure primaries or secondaries, so you need to think carefully before deciding, for instance, which green is a true complementary color to which red. Crimson is a bluish red; therefore its complementary color is going to be a green that leans toward yellow, rather than blue. A pair of complementary colors is often used to enhance a painting. Equal use of each color in a picture can result in a kind of stasis, whereas a small amount of one can energize a large area of the other.

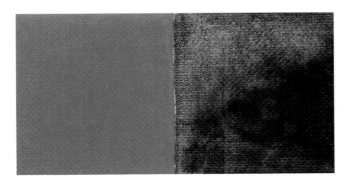

Cadmium red is an opaque pigment, so it does not need to be thinned to obtain its greatest luminosity. On the other hand, Hooker's green deep is transparent, and a thin layer will appear much brighter than a thick layer. In many landscape paintings where green is predominant, a touch of red can save the picture from being too dull or heavy.

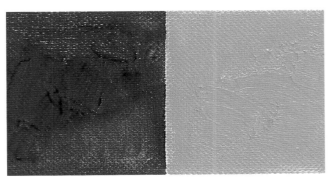

Ultramarine blue is transparent, whereas cadmium orange is opaque. You will find that it is not possible to mix a shade of orange from red and yellow pigments that is quite as bright as cadmium orange.

Permanent mauve is a transparent color, and it needs to be painted thinly enough to reveal its luminosity. This pair of complementary colors has the greatest difference in tone. In a painting of a sunny beach, it's a good idea to offset hot yellows and whites with blues and mauves.

What are tertiary colors, and how can I mix them?

Tertiary colors are browns, grays, and neutral colors, created by mixing two complementaries—in effect, by mixing the three primaries. If you mix together three primary colors—for example cadmium yellow, cadmium red, and ultramarine blue— you will make brown. The exact hue of brown will depend on the proportions of the colors used—if there is more red in the mix, a reddish brown will result.

You can also create grays by mixing together any pair of complementary opposites and titanium white. These grays will vary enormously, depending on the pigments you choose. If the gray appears too brown, add a little blue, green, or violet to cool it down. If it is still too warm (brown), add blue. If it is too dark, add white to lighten it. A true neutral gray is quite tricky to mix because the colors have to be balanced so that no single color is dominant. Grays can be pinkish, greenish, or bluish—in fact, like browns, they can lean toward many colors. To bring a gray back to neutrality, add the complementary opposite in small quantities until you have it right. If it is too yellow, for example, add a little mauve.

Blend together cadmium orange and ultramarine blue to create a brown. Each pair of complementary colors produces a range of different browns, depending on the proportion of each color in the mix.

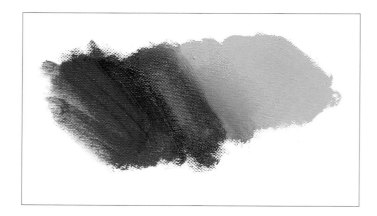

Mix together cadmium red and Hooker's green deep to create a rich reddish brown. Other pairs of reds and greens will create different browns. Pair different reds with different greens to see which browns you can create.

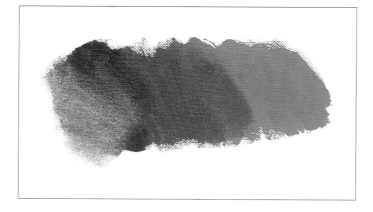

Blend cadmium yellow and permanent mauve to create a light brown. A surprising range of browns—similar to yellow ochre and raw sienna—can be mixed from these two colors.

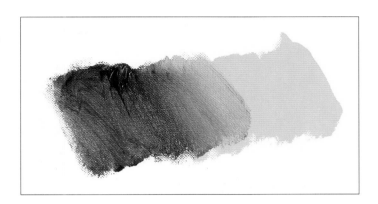

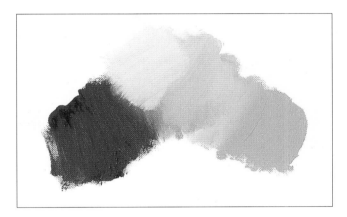

Mix ultramarine blue and cadmium orange together with titanium white to create gray. Add a small amount of white to obtain a medium or dark gray; add more titanium white to make a light gray.

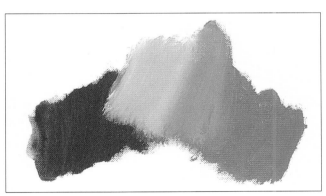

Blend cadmium red and Hooker's green deep together with titanium white. A wide range of grays, both light and dark, as well as warm and cool, can be achieved with these colors.

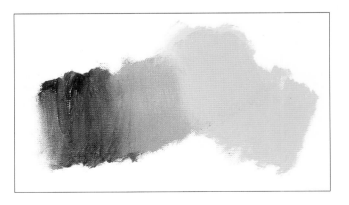

Mix cadmium yellow, permanent mauve, and titanium white. These colors make subtle, beautiful, neutral tints.

What is the most effective way to blend colors directly on the canvas?

When two areas of color meet on a canvas, there are all sorts of ways they can be blended together, depending on the type of brush used, the direction of the marks, and the amount of time spent smoothing out the paint. To create a smooth blend, where the colors gradually merge into one another, gently sweep your brush across your paper in regular strokes. For a rougher blend, where the colors retain individuality as they intersect, apply the paint more irregularly. Blend a third and fourth color to see the tonal and textural effects you can achieve, but remember that too many colors in a mix will make it muddy.

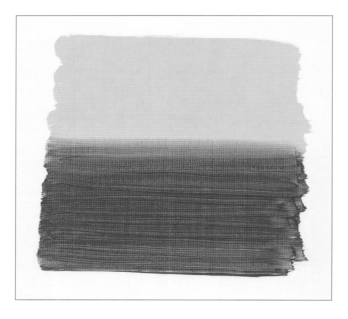

Apply both colors using horizontal brush strokes to create a smooth blend. In the example above, lemon yellow and cerulean blue were blended together to create a green. The horizontal strokes produced a soft, unfocused effect, ideal for merging the colors of a sunset or for creating the hazy appearance of mist. This is also a useful technique for blending two shades of the same color, such as where a shadow gradually darkens an object.

Apply two colors with loose, irregular brush strokes to create a rough blend. In the example above, cerulean blue and lemon yellow are roughly blended together to produce this lively impression. This technique would be useful for creating the effect of spray from waves or wisps of cloud in the sky. This is also a useful technique for lightly blending two shades of the same color, such as where there are many shades of green in foliage.

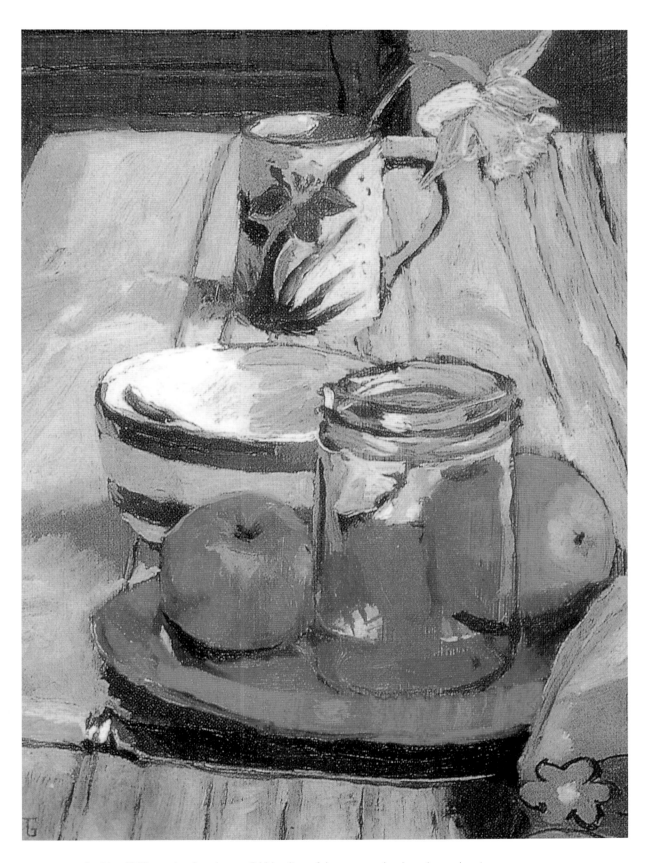

In this still life, notice that the careful blending of the green and red on the apples gives them shine and makes them appear rounded. Similarly, the blending of the whites and grays creates a subtle shade change and denotes the curve inside the bowl.

What is the most effective way to blend colors directly on the canvas?

How do I choose a background color?

The visual impact of a color is dramatically affected by the colors around it. White backgrounds tend to mute pale hues and overstate darker ones. Select a colored background that works with your subject, contrasting positively with it. Contrasts can be tonal (light and shade), chromatic (color value), or both, but they should neither overpower the subject of the painting nor make it too stark.

On a white ground, the dark brown petals stand out sharply, but the yellow gets lost because it is both tonally and chromatically close to white. The green petals are neither too sharp nor too soft in contrast.

On a yellow ochre background, the cadmium yellow flower almost disappears; only the dark brown is visible.

A pale permanent mauve background contrasts chromatically with the yellow petals. This has a more dramatic effect than the white or yellow background.

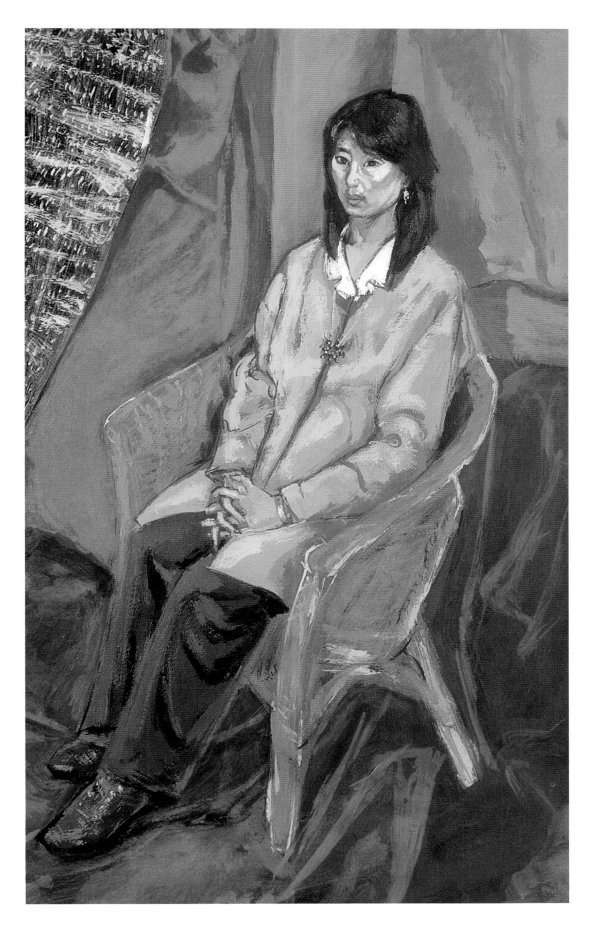

The palette for this colored background consists of strongly contrasting colors and shades, integrating the subject with the model's surroundings. Warm/cool and light/dark contrasts are beautifully balanced. A bright ultramarine underpainting shows through here and there between the warm colors of the portrait, further enriching the colors.

What is a glaze, and what effects can I achieve with it?

A *glaze* is a layer of thin, usually transparent paint, brushed over another, dry, layer to alter its color. Glazes can be used to enrich or tone down the color beneath. Build up layers of glazes to create bright or deep glowing colors and make the painting shine. Mix the paint with a glazing medium—fast-drying alkyd medium is available in art supply stores—or mix a home-made glaze with equal parts of linseed oil, dammar varnish, and turpentine. This mixture can be further diluted with more turpentine, up to about four parts turpentine. Use a soft brush rather than a stiff bristle, so that the brush marks do not show. As with paint, the golden rule is to work from "lean to fat." This means first layers should contain less linseed oil than subsequent ones.

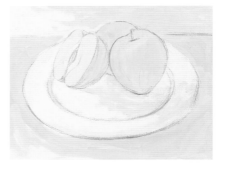

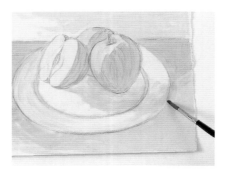

1 Dust your charcoal sketch with a piece of cotton wool to keep any loose particles of charcoal from dirtying the glazes. Leave only a ghostly impression that will disappear into the paint layers as the picture develops.

2 Start with a lemon yellow glaze diluted with glazing medium and a little turpentine. Paint the background, apples, plate, and table which will become brown and green after further glazes are applied.

3 Once the first glaze has dried, apply the second glaze to the shaded side of the apples and plate using a mix of cerulean blue and glazing medium. This will react with the yellow glaze to create a green.

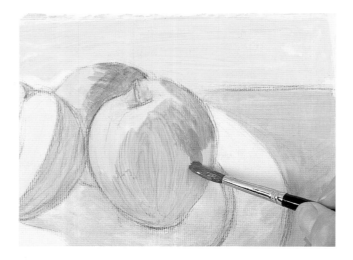

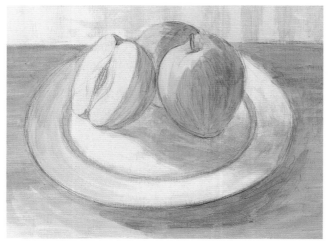

4 Tint the apples with cadmium red thinned with glazing medium. To produce the illusion of volume, brush the glaze in a different direction from the blue glaze applied previously.

5 Although the painting at this stage has received three glazes, it still looks too pale. You need to add further glazes to make the colors richer.

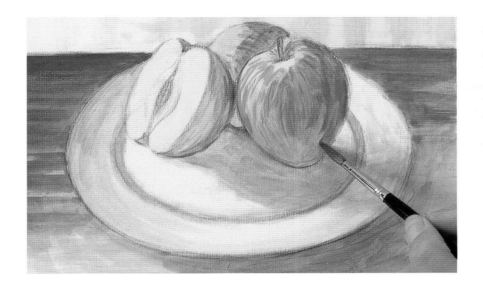

6 Add a second, stronger glaze of cadmium red deep to develop stripes on the apples and to darken the table top. Apply glazes thinly to avoid a "sticky" looking surface. If the result is too pale, add more paint to the mix. But always add glazing medium to each paint layer and allow it to dry before applying the next.

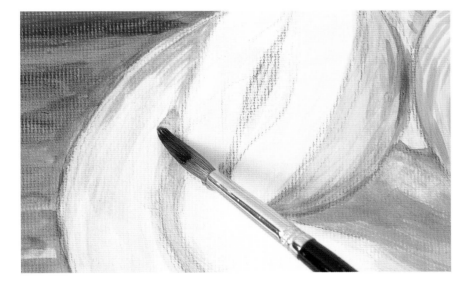

7 Apply a final glaze of ultramarine to deepen the shadows. This will help create a sense of depth and three dimensionality.

ARTIST'S NOTE

A good mix for a glazing medium would be 1 part linseed oil, 1 part dammar varnish, and 1 part pure turpentine. Combine these ingredients in a screw-top jar. Pour some of the mixture into a small painting cup, and dilute the mix further with more turpentine for the first layer of glaze, less on the next, and so on. If you are applying a glaze over a thick layer of dry paint, the glaze should contain a little more oil than the layer before it.

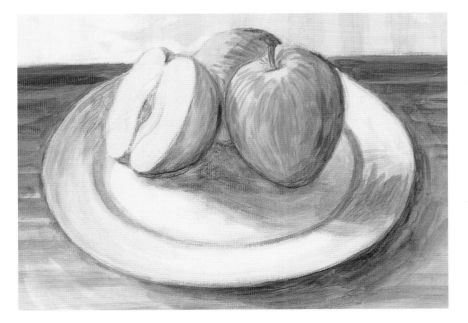

8 In the finished painting, notice that the charcoal drawing has disappeared underneath the glazes. However, the glazes glow through one another, adding depth and life to your painting.

What does glazing over a textured surface do?

Glazes are a little like colored glass in that they are transparent, allowing light to penetrate. Oil glazes can be used over textured paint surfaces—created either with acrylic texture paste or with thick oil paint that has been allowed plenty of time to dry—to alter the depth of hue in the pigments and add to the visual impact of the textured surface.

1 Use a tough brush, such as a hog bristle, to apply a glaze over a rough texture. A more delicate hair brush will get damaged. In this example, cadmium orange mixed with glazing medium is brushed over an acrylic textured surface, using a round hog brush. Because the paint is already heavily textured, you can apply these glazes quite roughly.

ARTIST'S NOTE

Some common transparent pigments are aureolin yellow, lemon yellow, Indian yellow, scarlet lake, alizarin crimson, permanent rose, carmine, crimson lake, magenta, permanent violet, Prussian blue, indanthrene blue, monestial blue, French ultramarine, indigo, monestial turquoise, alizarin green, sap green, Hooker's green, viridian, transparent gold ochre, raw sienna, burnt sienna, brown madder, burnt umber, and raw umber.

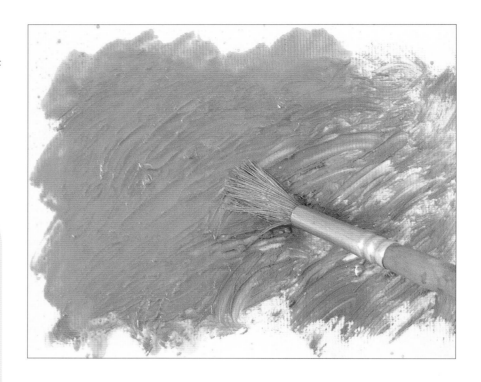

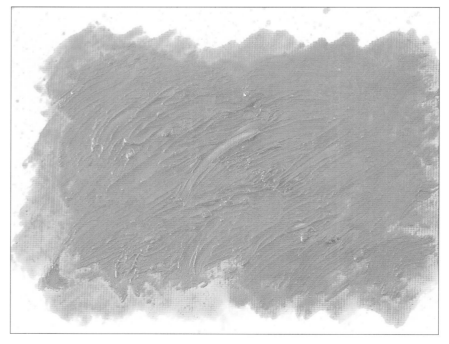

2 The glaze transforms the color of the texture paste from a dull beige to a glowing burnt orange, giving it a rich, glossy finish.

Why would I select one glaze over another?

Some glazes enrich colors, others tone them down. A glaze can make a sky more intensely blue or a sea more deeply green. A translucent or semi-opaque glaze (one made with an opaque pigment, such as cadmium red or titanium white) can produce a milky or veiled effect. The choice of pigment for a glaze is important because some are already transparent by nature, whereas others are inherently opaque.

ARTIST'S NOTE

A translucent glaze of titanium white and alkyd medium brushed over the crimson vein of a leaf produces a pale, bluish violet. As well as lightening a color, a pale translucent glaze over a darker color will appear to cool it.

1 Tone down the middle ground with a glaze of permanent violet. Stroke the glaze thinly across the surface with a round sable brush.

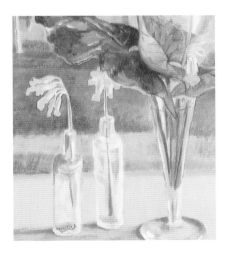

2 The half-completed glaze shows the dramatic change of emphasis it can achieve.

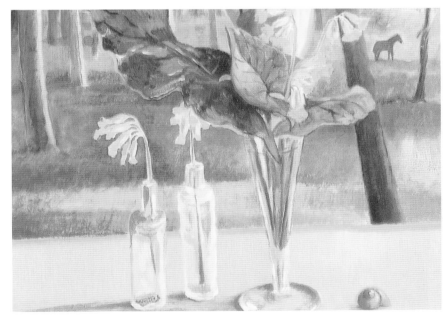

3 The completed picture shows the yellow cowslips glowing against the darker middle distance, painted with their complementary color, violet.

D Demonstration: Poppy landscape

Many painters adore using a rich, colorful landscape as a subject in oil. The range of color and tone in nature allows for vibrant hues and interesting brushwork. In this example, impasto painting with a brush and a knife creates the varied textures of the landscape, while glazes are used to cool some areas of the painting without reducing the overall impact of the vibrant color of the poppy field.

1 Lay down a blue ground of ultramarine thinned with painting medium, and use the same color to draw the outlines of the elements.

2 Mix impasto medium (*see* page 19) with all the colors to make them really thick. Paint the sky with a mix of ultramarine, raw sienna, and titanium white. Apply the paint generously with a filbert hog and loose brush strokes. Then add more white for the clouds.

3 Add a little permanent mauve to the previous mix, and swirl this into the color already applied to imitate the movement of the clouds.

4 Paint the hill with a mix of alizarin green, Hooker's green, and impasto medium. Use rough brush strokes to keep texture in this dark expanse of color.

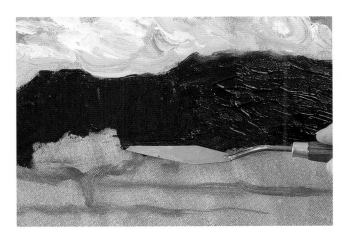

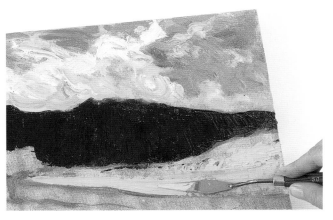

5 Smooth out the paint on the hill with a palette knife to remove the obvious brush strokes. This area should be smoother than the trees below, to differentiate it from the rest of the landscape, but it should not be a sheer flat area of color.

6 Clean the knife with a cotton rag; then mix lemon yellow with a little Hooker's green and white for the distant field. Drag the color across the canvas with the flat of the knife.

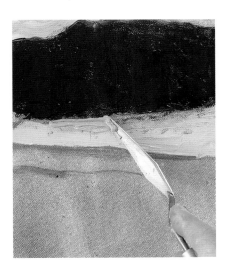

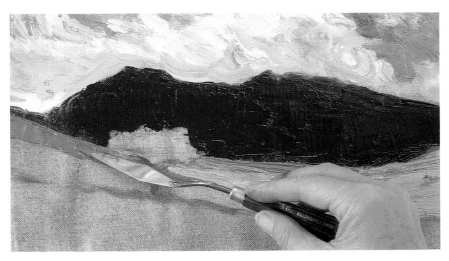

7 If you make any mistakes, scrape off the paint with your palette knife.

8 Mix a darker shade of yellow using raw sienna with a little cadmium red deep and Hooker's green. Apply the color over the existing bright yellow.

9 Mix a dark green from Hooker's green deep and alizarin green for the distant trees. Then add a little cadmium red to warm and darken the greens.

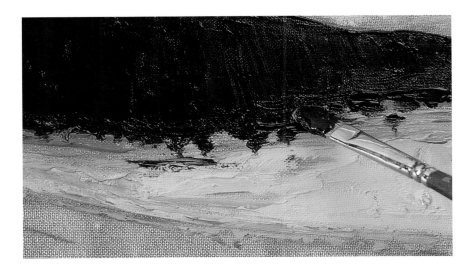

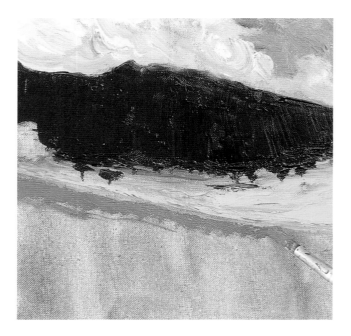

10 Paint the distant poppies with a mix of yellow ochre and cadmium red using a round hog brush. Apply the paint in horizontal strokes, and loosen the brushwork as you work toward the foreground.

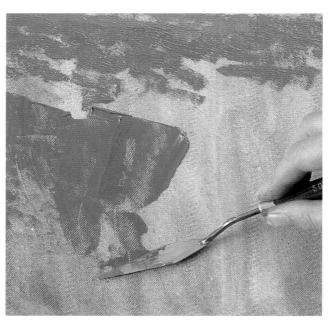

11 Apply broad vertical strokes of lemon yellow, Hooker's green, and a bit of white with the knife. You need to cover the foreground with a generous layer of paint as a base for other colors you'll add later.

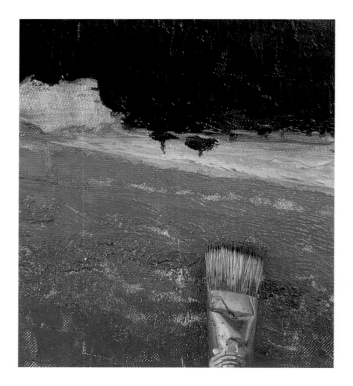

12 Stipple some of the foreground color into the poppy red in the middle distance. Use an old flat hog brush to get an uneven covering so the red will show through in places.

13 Drag the same green mix over the earlier knife work to create a rough texture suggesting grass.

14 Mix a paler tint of green with lemon yellow, Hooker's green, and titanium white. With the edge of the filbert brush, paint short vertical strokes for the foreground grasses.

15 At this stage, the painting has a sense of depth with the dark greens in the distance drawing the eye deep into the picture.

16 Mix a darker green using Hooker's green deep and a touch of cadmium red. Use the edge of your palette knife to make small vertical strokes to indicate areas of shadow between the clumps of grass.

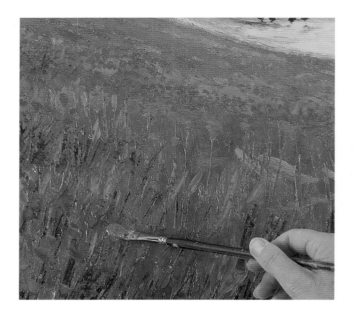

17 Paint the poppies with cadmium red and a small filbert. Vary the size and shape of the strokes as you paint deeper into the picture space. Carefully adjust the size of the most distant strokes so they merge with the bands of red painted earlier.

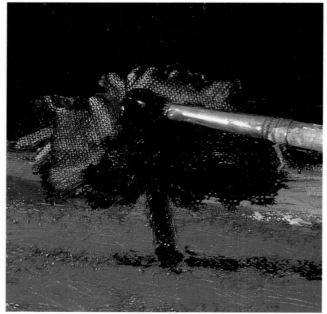

18 Use the edge of a filbert brush to paint white daisies with a mix of titanium white and impasto medium. Make the marks smaller and less clearly defined the farther away they are.

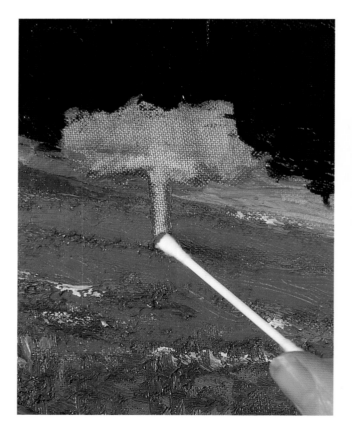

19 Clean the paint away from the trunk of the large tree with a cotton swab dipped in turpentine. This will give you a clean area so the next color won't get muddy.

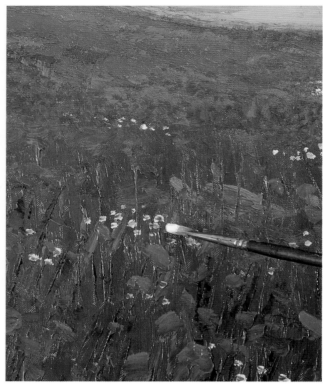

20 Paint the tree with a mix of Hooker's green deep and a little lemon yellow and cadmium red. The tree needs to be dark, you don't want it to unbalance the painting. Rather than darken the tree, adjust the hue of the hill.

21 Wait until the hill is dry, and then apply a semi-opaque glaze of ultramarine, permanent mauve, and titanium white to push it back in the picture space and separate it from the tree. Apply it roughly so that the brush strokes give it texture.

22 At the moment, the yellow of the field is too sharp. Balance this area with a thin layer of cobalt blue glaze over the left-hand side of the field. This will make the field recede in the picture.

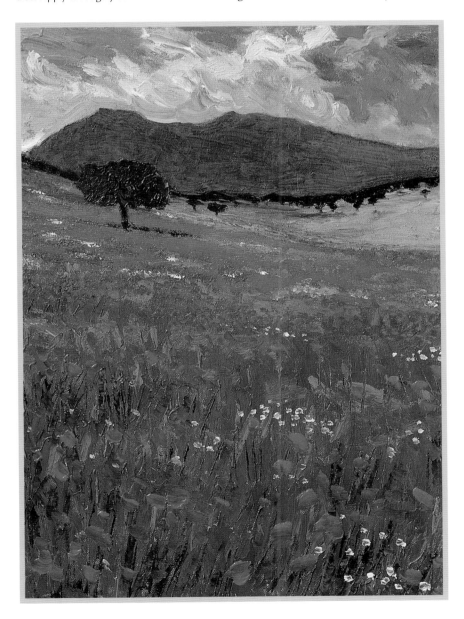

23 The hill is now paler and more blue, distinct from the row of trees at the far side of the yellow field. The blue glaze has pushed it back a long way, introducing a sense of depth using atmospheric perspective (*see* Chapter 4).

3
Composing and painting still life

A still life is one of the most popular and rewarding subjects for oil painting. Unlike landscapes and portraits, where the subject matter moves or is prone to changes in light, a still life offers an artist complete control over composition, lighting, subject, and time—a bowl of fruit does not get tired or have to change positions. However, a still life requires just as much careful composition and attention to detail as any other subject matter.

Sometimes, ordinary and familiar objects are the best things for beginners to paint. They have as much aesthetic potential as exotic items, but are more readily available. However, it is often easier to make a close study of an unfamiliar object than to focus on an everyday familiar one. There is less temptation to think you know what the objects look like rather than studying them closely.

The objects in a still life usually occupy a small space, making these paintings essentially intimate. As soon as one object is joined by another, a relationship is created between their colors, forms, light and shade, texture, scale, and proximity. The relationship can be close or distant, depending on the nature of the objects and where they are positioned in the picture.

Objects displace space; so setting up a still life is a contemplation of the interaction between space and form. Begin simply, with perhaps just a couple of pieces of fruit on a plate. Look at the relation of the objects to one another, the spaces created between them, and the spaces created by the edges of your picture-space. Try to construct a still life with echoing shapes and related objects, so that the viewer's eye is led around the canvas from one focal point to another without visual jarring.

As you master the genre you will find that there is an opportunity for endless variety in your compositions. This chapter offers help with—among other things—representing three-dimensional form, the appropriate degree of detail to use when painting flowers, and capturing the shine of metal and the glint and reflective quality of glass.

How do I select the best format for my still life?

The format is often dictated by the objects in your still life arrangement. Set up your still life, and then make a simple viewfinder with two small L-shaped pieces of card fixed together with paperclips to create a rectangle.

Hold this viewfinder a short distance from your eye to frame possible formats. Looking through a small frame in this way allows you to see a number of interesting compositions. You can also adjust your viewfinder to a landscape, portrait, or square format. Observe the height and shape of your objects, and select a format that makes your composition visually interesting.

This brush drawing of a still life includes the objects and their shadows in a long, horizontal format. The bottle is placed in the center of the composition, which is not the best use of the space because it divides the composition too rigidly in half.

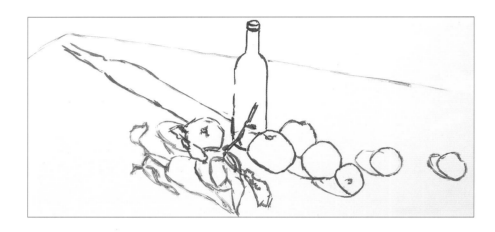

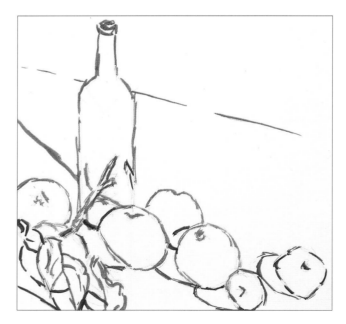

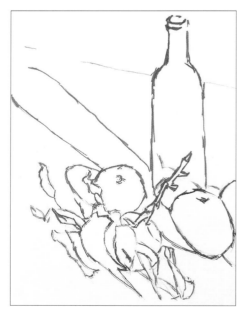

In this square format, the bottle is to the left, and the apples spread across the foreground in a pleasing, gentle diagonal. This is a formal, calm composition that draws the eye in a sweeping curve from the top of the bottle to the right-hand apple.

In this study, the format is a vertical rectangle, commonly called "portrait format." The bottle is now on the right, leaving space for its shadow to take the eye toward the top-left corner of the picture space, creating a dynamic composition.

What are negative spaces?

Negative spaces are the gaps between objects. Often, too little attention is paid to negative space because the focus is on the objects themselves. However, these spaces link one element of a composition to another, and so they need careful scrutiny.

When you are organizing a composition, pay equal attention to all its parts, whether or not they contain something tangible. The shapes created by negative spaces are as precise as the shapes of any solid objects, and they help define the objects' forms. Practice painting only the negative spaces in a composition to see clearly how the shapes of the objects are revealed.

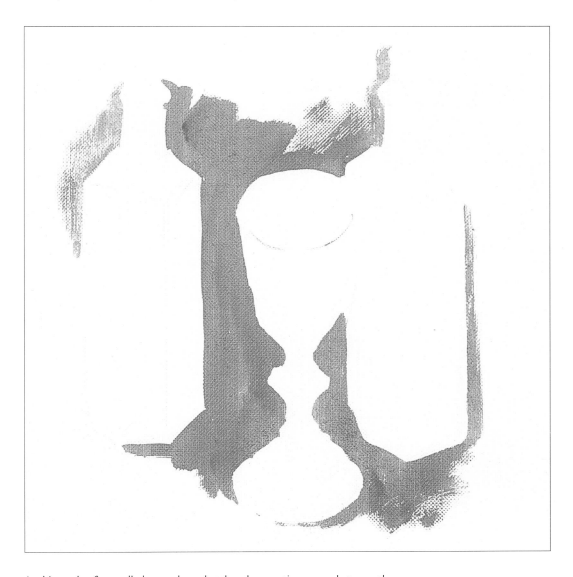

In this study of a small glass and two bottles, the negative spaces between the objects have been blocked in with rose madder without any outline sketch.
The objects appear as white cutouts, yet their shapes are clearly recognizable.

How can I give objects a believable three-dimensional form?

Three-dimensional form is created by the play of light and shade. Any object can be given depth if it is rendered with both a lit and a shaded side and given a *cast shadow*—one cast by an object onto a surface. Observe the objects carefully, noting where the light and shade fall and how gradually the tones move from light to dark.

A gradual darkening usually denotes a curve. A sudden shift from light to dark is most likely to occur at a hard edge. You may find it easier to see these effects if you light the objects with a spotlight so the shadows are very pronounced.

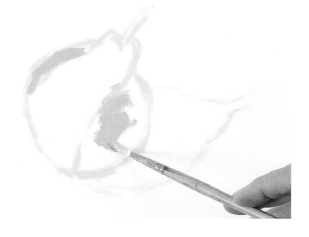

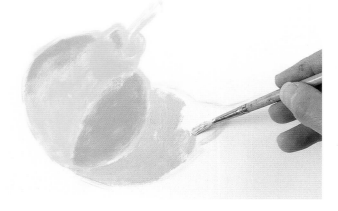

1 Draw the outline of the pear using one of its palest colors. Placing a heavy edge on the light side is a common error and renders an object more two-dimensional. Block in the pear with mid-tones, palest where the light hits and darker in the shadow.

2 Next block in the cast shadow. The color of the shadow will give an impression of the quality and brightness of the light; the shape of the shadow will suggest the position and direction of the light source.

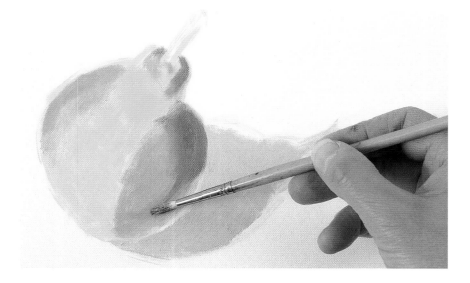

3 The shadow sides of objects are not usually one color, nor are they necessarily simply a darker version of the color in the highlights. To give the sense of a curved surface, gradually lighten the shadowed color of the object slightly as you paint toward the light.

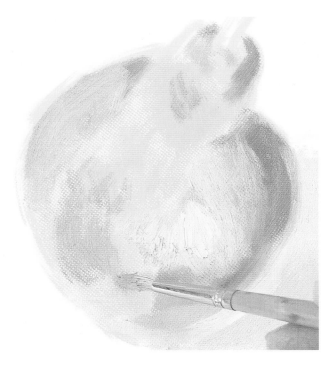

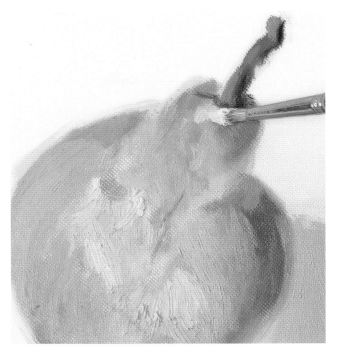

4 Now paint the areas that are neither fully lit nor fully in shadow. The movement from dark to light will create the form of the object. Note here that the underside of the pear is not the darkest area, as some light is reflected back onto it from the tabletop.

5 Add highlights to the areas where the light is strongest. Once the body of the pear has a three-dimensional look, turn your attention to the stem. The same rules apply, but the colors will be darker.

ARTIST'S NOTE

Shadows become paler the farther they are from the object casting them; the contour of the shadow also softens along the shadow's length, elongating the shape. It is important to note that shadows are never entirely black and light is never pure white. Shadows can be a mix of many colors, and the light sides of objects reflect the colors that surround them.

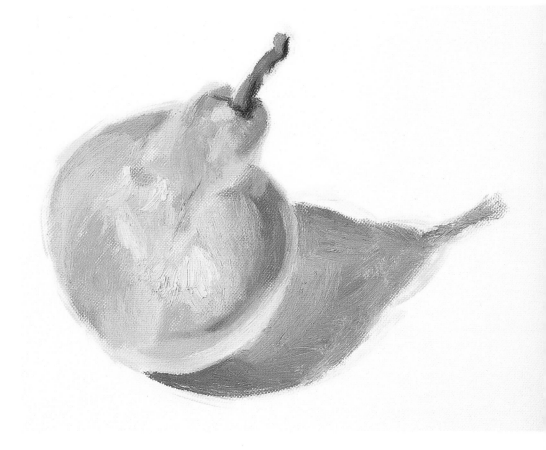

6 Finally, paint the cast shadow directly under the object. Gently blend the colors of the shadow to show that it gets lighter the farther from the object it is. Be subtle—too much contrast from light to dark in the shadow will look unnatural.

I find I spend too long on each area of the painting and end up with patchy results. How can I remedy this?

Whatever subject you choose to paint, it is all too easy to create imbalance in a painting. This can be caused by too much detail in one area, colors that sit uneasily together, or perhaps a wholly different style of painting from one area to the next. Fortunately, the process of creating a painting can be simplified into a few logical steps.

If you follow these and apply them to the canvas as a whole, your paintings will develop a sense of unity. Once you are familiar with the guidelines outlined here, you will be able to apply them to any subject.

1 Paint the main outlines of the objects in a pale mid-tone. Include outlines of shadows, as these are an integral part of the composition. Do not leave any area "for later." You need to have an overview of the painting from the outset so that you can remedy any problems of composition or format as early as possible.

2 Block in the main areas of color using a pale hue or mid-tone color found in the object. It is always easier to darken a hue than to lighten it. Block in each area so that you can see how the colors interact.

3 Next, block in the areas of shadow throughout the entire composition. Keep the shadow tones even—the lightest and darkest areas of shadows from the same light source will have the same density, even if they are cast in different colors.

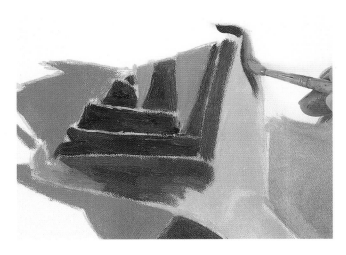

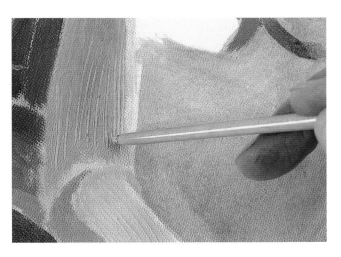

4 Now paint the more specific areas of color, comparing each new color or hue to the painting as a whole. Blend and vary the tones from light to dark, building up the color and form of the objects.

5 Once the main colors are correct, add the fine details and finishing touches, such as detailed texture. Don't overwork any single area of the painting.

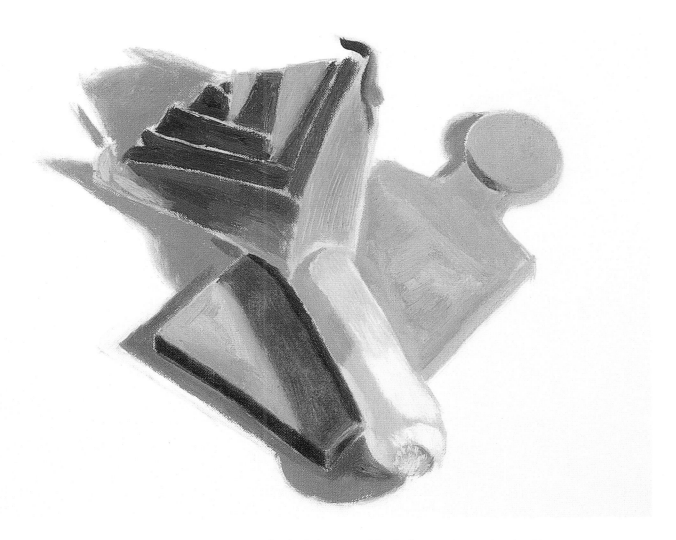

6 Finally, check the tones of the shadows again now that the objects are finished. The shadows may need darkening to balance the colors.

I find I spend too long on each area of the painting and end up with patchy results. How can I remedy this?

Groups of flowers seem intimidating because there are so many minute details. What is the best approach to take?

With a complicated subject, such as a bouquet of flowers or dense foliage, you must decide whether to paint every petal and leaf or whether to interpret the subject more simply. If you choose the latter, you can still make your flowers look realistic and delicate without painting every detail. Use color and brush stroke techniques to manipulate the paint and imply the shapes of the petals and leaves. Blend colors to add depth to your flowers and give them shape without becoming too fussy about accurately rendering each petal.

1 Paint a rough sketch of the flowers with a mix of zinc yellow diluted with turpentine. Keep your drawing quite loose and free, and avoid getting caught up in the detail.

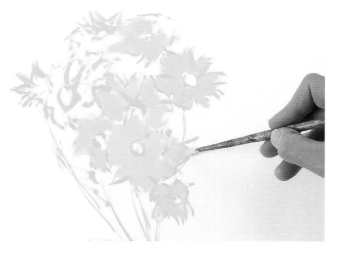

2 Block in the flower shapes with a mix of zinc yellow and titanium white. Apply this quite freely, still ignoring the details of the petal shapes.

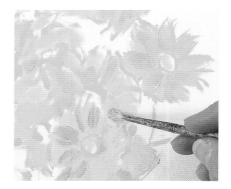

3 You can create the impression of petals by applying shadow. Using a cooler color, paint the shaded petals with a mix of permanent mauve, zinc yellow, and titanium white.

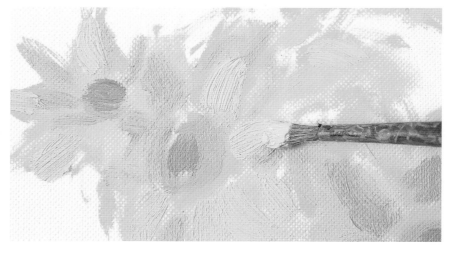

4 Using a mix of cadmium yellow and zinc yellow, define the centers of the flowers. Add this lighter color to some of the petals to give them a hint of definition.

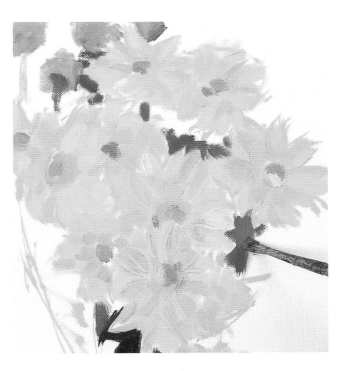

5 Leave some of the yellow drawing visible in places at the edges of the flowers. This will help define the shapes of the petals.

6 Next add the leaves. Instead of painting each one in great detail, create a mix of zinc yellow, titanium white, and green and paint each leaf in varying tones.

ARTIST'S NOTE

Mixing colors for flowers takes a little practice. Keep the colors you mix together to a minimum; mixing too many colors together can make your colors muddy. Do not add black or brown to the petals to create a shade; instead, add a touch of blue. For yellow flowers, use mauve or yellow ochre to subtly darken them.

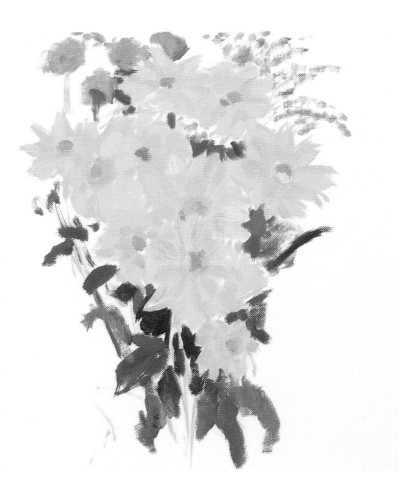

7 A splash of color will hint at the flowers and leaves that are not entirely visible. Very little detail has gone into this painting, but it is still recognizable as a group of flowers.

Groups of flowers seem intimidating because there are so many minute details. What is the best approach to take?

Painting flowers can be a challenging subject for beginners. If you are painting from life, you need to paint relatively quickly before the flowers wilt. You do not need to paint in great detail as petals can be implied with brush strokes and varying tones of color (*see* pages 54–55). Painting flowers against a colored background, as in the example below, can work to your advantage, you can leave parts of the background revealed to create detail, light, and shade.

1 Cover the canvas board with a lemon yellow ground. If you want to begin painting right away, use acrylic paint, as it dries quickly. Spread the paint thinly, so the canvas is evenly covered. Working in oil, use a rigger brush to make an outline drawing with a mixture of lemon yellow and cerulean blue. Place the jug off-center, so that the flowers can spread into the space. Keep the drawing simple, and indicate only roughly where you will place the main flowers and leaves.

2 Using a sponge dipped in cadmium yellow deep, paint dabs of color where the yellow flowers will be. (You will paint over these later.)

3 Load a large decorator's round bristle brush with a mixture of lemon yellow and cerulean blue, and dab and roll it around to indicate where the main leaves will be.

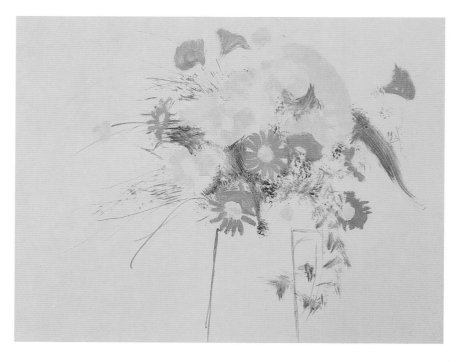

4 Now you can begin to apply the strongest colors. Add the brightest color first, with a mix of alizarin crimson and titanium white. Take care not to add too much of this strong pigment at a time, so you remain in control of the values.

5 At this stage, you can see that the main design is established, capturing the quality of lightness and fragility.

6 Paint the main body of the jug with titanium white. Then lightly blend in a little cobalt blue on the left side of the jug to create shade.

7 Load a round brush with titanium white for the pure-white flowers. Paint thickly, using the impasto technique to suggest texture, light, and shade.

8 For the dark pink flower, mix magenta, permanent mauve, and a little titanium white. Use a filbert brush, taking advantage of its slim shape to help define the long and short petals.

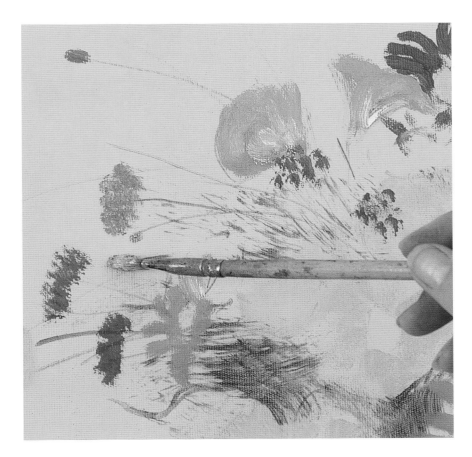

10 Dab some white into the centers of the flowers to fill their contours. Then paint wet-into-wet with permanent mauve to add a sense of depth to the center of the flower.

9 Stipple a mix of cobalt blue and titanium white to create the impression of cornflowers.

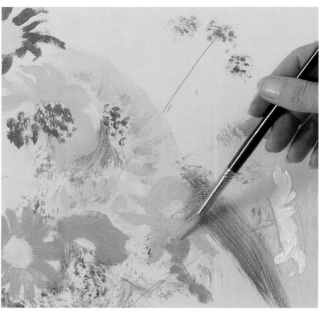

11 Next, add splashes of cadmium yellow to the centers of the purple flowers.

12 Use cadmium orange to strengthen the yellows of the deep yellow flowers to make sure they stand out from the yellow background.

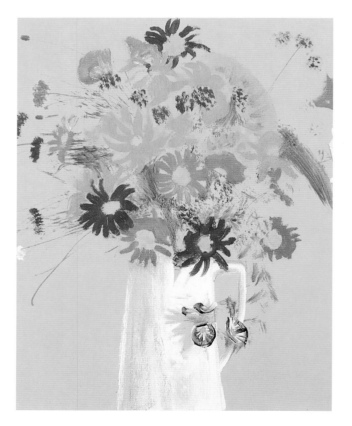

13 There is no need to paint every petal. Notice that the bright yellow background helps define the petals despite their slightly unfinished shapes.

14 Add highlights to the red centers of the flowers using a rich mixture of cadmium orange, alizarin crimson, and permanent mauve.

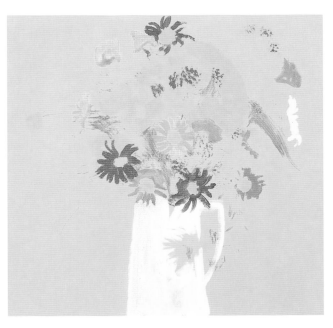

15 Paint the leaves using a mix of lemon yellow, cobalt blue, a touch of alizarin crimson, and titanium white. Vary the tone according to where the light falls.

16 As you continue painting the leaves, keep the greens neutral so that they do not clash with the colors of the flowers.

17 The centers of the daisies are quite textured. Apply a brown made from cobalt blue, cadmium orange, and titanium white. Then create texture by gently stippling on a warmer mix of the same colors.

18 To keep the picture looking fresh, work quickly and complete the picture in one sitting. Here you can see that you do not need to paint a lot of detail to create visual impact.

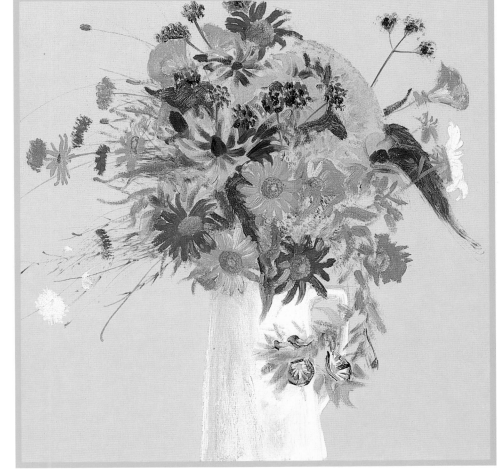

My glazed, white crockery looks flat and dull. How can I correct this?

Painting glazed, white crockery presents two challenges: developing believable forms, and re-creating the texture of glazed china. First tackle the shapes. Viewed from the side, the top of a cylindrical object is foreshortened from a circle to an ellipse. An ellipse is not an oval, which is horizontally and vertically symmetrical; thus the back curve of an ellipse is flatter than the front curve.

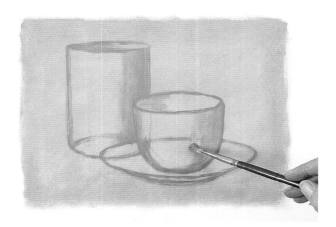

1 Paint the background first with a mix of titanium white, raw sienna, and cobalt blue. Using a darker mix of the same colors, draw the basic outlines of the mug, cup, and saucer. To get the correct shapes, draw the complete ellipses—the bottom of the mug and the rim of the saucer. Using the same colors but with more raw sienna, indicate the shadows—even though they won't be visible.

2 With a slightly paler but warmer mix, block in the objects completely, obliterating the unseen sections of the ellipses. Also, blend the color into the darker tone as you work. This will make the objects appear solid.

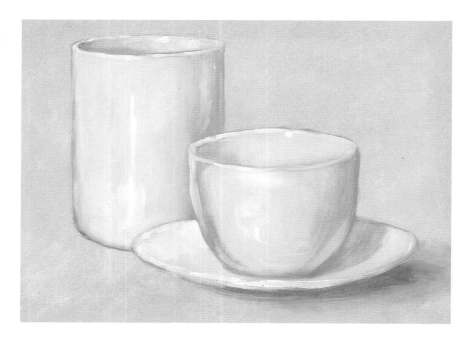

3 Finally, apply the highlights with pure titanium white to bring the glazed china surfaces to life. With a slightly darker color, add some light in the shadow areas, where it is reflected back from the surroundings.

What are some tips for painting folds in cloth?

Fabric is often thought of as a difficult subject. The more complicated the folds and wrinkles, the more likely you are to get lost trying to draw it. Begin with something simple, and use a single light source to keep the shadows and highlights separate. Apply the base color first, and then start to build up the shadows on the cloth; these will define the folds. Then you can start painting the highlights, which will further define the undulations and creases in the cloth.

1 Draw a basic outline and apply the base color with a round hog brush and a mix of cadmium orange and painting medium. Let this layer dry.

2 Sketch the basic folds of the cloth and then work on the shading with the same color. Use a more concentrated mix where the shadows are darkest, and lighten the color by brushing more thinly over the lighter parts of the cloth.

3 Paint the highlights with a mix of titanium white and a touch of the base color. This helps to define the gentle curves of the cloth.

ARTIST'S NOTE

Cloth—folded or creased—is a common element of still life paintings. Use white cloth to show up cast shadows and choose patterned cloth to reflect back onto shiny or white objects, giving more color interest to the painting. The folds in cloth can also be used to lead the eye around the composition.

How do I create the sense of uniform stripes or pattern on draped cloth?

If plain fabrics are difficult to paint, then stripes and patterns add even more complexity. As for plain fabric (*see* previous page), drawing is the key. You will find it easier to draw the folds first, and then add the pattern. The pattern on a piece of cloth follows the peaks and troughs of the folds so, rather than being continuous, the lines of the pattern will stagger as they pass out of sight and back into view. Then paint the main colors first and enhance the folds of the cloth with shading and highlights.

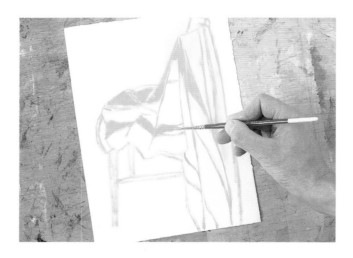

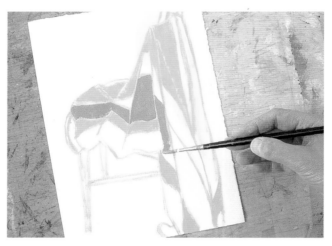

1 First, draw in the outlines of the objects with a mid-tone color of the cloth. Any solid forms should be clear beneath the fabric—the folds of the cloth will not make sense by themselves. Draw the shapes made by the folds first, then draw the stripes or pattern. Apply your first block of color with the mid-tone you used for the sketch.

2 Apply the second major color—in this case, a mix of red violet, cadmium red hue, and titanium white. Look carefully at the cloth and faithfully repeat the staggered lines of each stripe.

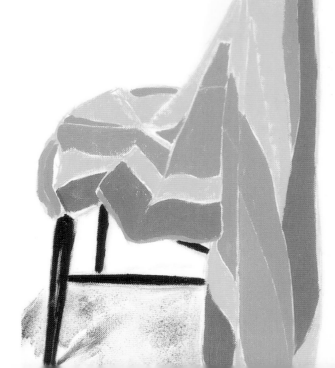

3 Block in the rest of the pattern colors so that the overall form takes shape. Here, the green stripes were painted next, then the purple, and then the dark structure of the chair. For the chair, mix cadmium red hue and ivory black. Use the same color, thinned with turpentine and painting medium, to lightly brush in the cast shadow of the chair.

4 Study the areas of light and shade. Using slightly darker mixes of the original colors, add shading to suggest the folds in the towel.

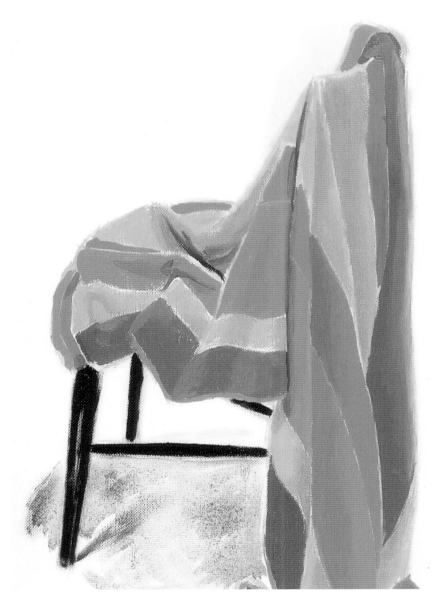

5 Mix the color of each stripe with titanium white to add the highlights. Place the highlights along the top of each crease and fold.

How do I create the sense of uniform stripes or pattern on draped cloth? **63**

How can I make metal look shiny?

First, shiny metal reflects the lights and colors that surround it, bending their shapes and creating distortions that are difficult to anticipate or invent. Also, the light source—whether artificial or natural—may be warm or cool, creating a color cast on the reflections. And, some metal surfaces have a high shine, while others are more dull, whether from age or finish.

Furthermore, the colors of copper and brass will tint all the reflections, whereas polished silver and steel will reflect color the way a mirror does. The key is to paint exactly what you see, even if the distortions look very strange. Practice drawing setups with simple shapes and strong colors, such as the one shown here, to get a feel for the changes in shape and color that reflections in metal can take.

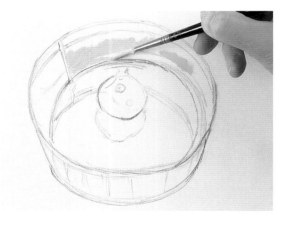

1 Draw the whole composition in pencil, including the principal shapes of the reflected colors. Here, the base and sides of the metal pan reflect the pale ceiling color. Paint these areas with a mix of titanium white and yellow ochre.

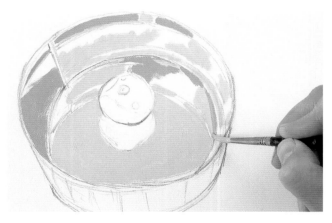

2 The pan is made from "white" metal—one with no hint of yellow, such as silver and steel—so where it is reflecting part of its own surface, the reflected color is a medium gray. Apply the gray using a mix of titanium white and ivory black.

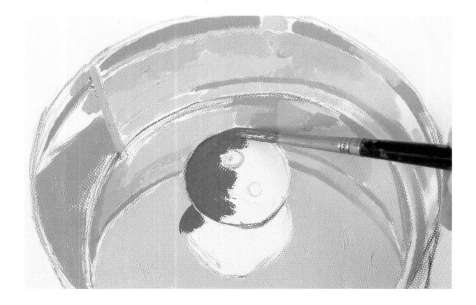

3 The medium red of the tomato is dark against the lightness of the pan. Using a mix of cadmium red and permanent red, start to paint the tomato. Also, begin painting the reflection underneath in the same color, as white metals do not influence the colors of the reflections.

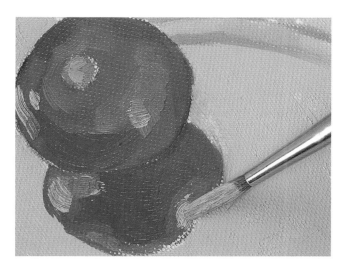

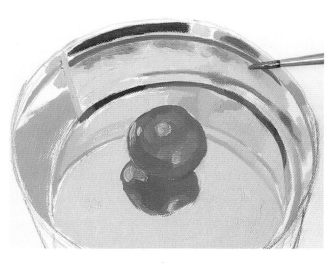

4 Paint the darker reds on the underside of the tomato and its reflection using alizarin crimson. For the yellowish highlight on the tomato, use a mix of cadmium yellow, cadmium red, and permanent red. Then, gently brush thin titanium white into the wet paint, blending it slightly so that the color is not too crisp.

5 The tomato is also reflected under the rim of the pan. This reflection is a darker, cooler red than the tomato itself because the underside of the rim is in shadow. Paint this with a mix of alizarin crimson and the gray mixed previously.

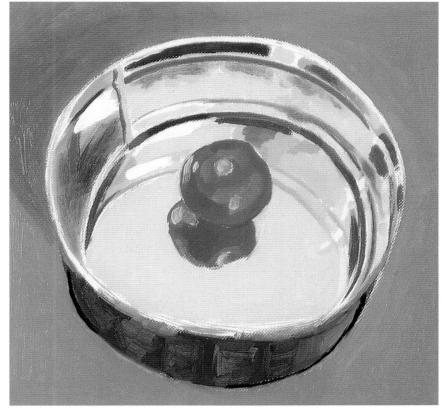

6 At this stage, the gray and the cream colors need some more light and dark variants to imitate the shine. Add some ivory black to the gray mixture to paint the darker shades. Work lighter tints into the cream area with titanium white, and use white straight from the tube for the highlights. The highlights will not gleam brightly unless the shaded areas are dark enough.

7 Paint the tabletop and add a touch of ultramarine to indicate the cast shadow of the pan. Then paint the outside of the pan with ultramarine, working in some yellow ochre wet-into-wet. The warm ochre background sets off the shine and reflective quality of the metal pan.

Are there any tricks for capturing the glint and reflective quality of glass?

Painting realistic glass objects is particularly satisfying because everyone thinks that glass is very difficult to paint. Just as a window reflects the light, which is what makes it visible, so any glass object will reflect light, bending the light rays to its shape. Anything behind the glass object will show through it but will also be distorted. However, you need to be selective when you paint. There are various degrees of brightness, and there may be a multitude of details. Focus on the most prominent light and dark shapes. Start with a basic outline of the glass and apply the darker tones first and the brightest highlights last. These extremes will bring the whole painting together.

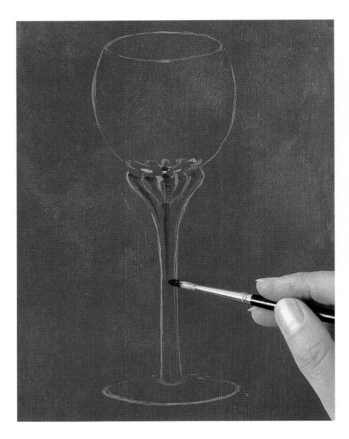

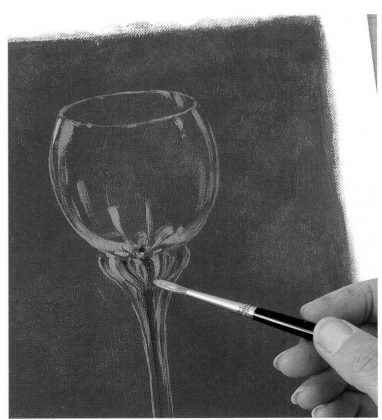

1 A rich color behind a glass will make the areas of light and dark very clear, this glass is standing on a sheet of deep blue paper to bring out its highlights. Paint the background using a mix of ultramarine and a touch of titanium white. Adding more white to your mix, paint the basic outline of the glass. Use a color that you know will be used later, so the outline does not look out of place. Then paint the thin core of black glass in the stem with a mix of monestial blue and permanent mauve.

2 Add the first highlights with the same pale blue used for the outline of the wine glass. Do not apply pure white yet. You should establish the darker tints first and then work toward the brightest highlights.

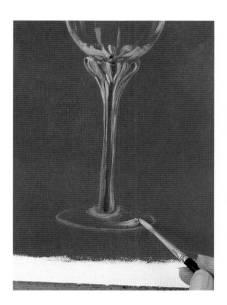

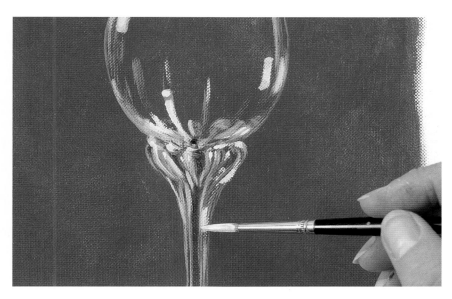

3 The highlights in the glass are not all the same color; the reflected light will be affected by the light source and other colors around the glass. Mix titanium white and a little yellow ochre with the pale blue mix, and apply the warmer highlights to the stem and base of the glass.

4 In this case, the brightest highlights are also warm. Using a mix of cadmium yellow and titanium white, create a bright but warm white and apply these highlights next.

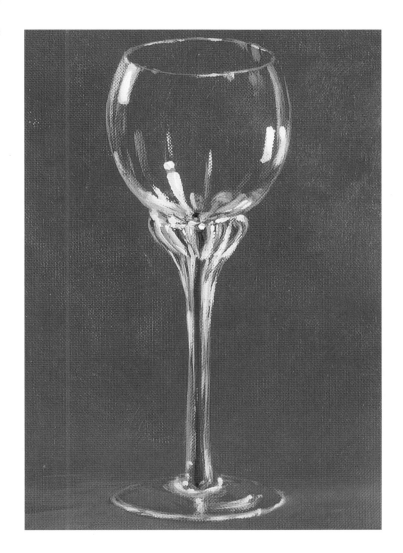

5 The light source is at the front, and the reflections that are visible on the far side of the glass are comparatively soft. The light on the rim of the glass is not one continuous color but brighter where the light catches it. Delicately paint this highlight with a fine rigger brush for the final touch.

Are there any tricks for capturing the glint and reflective quality of glass?

D Demonstration: Pumpkin still life

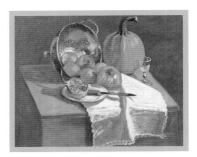

In this still life, the arrangement of natural objects with various kitchen utensils creates a lively composition. The metal colander reflects the vibrant colors of the apples and pumpkin, while the knife and white cloth create interest in the foreground, drawing the eye toward the more colorful objects farther back in the painting. The rich background color creates a dramatic contrast.

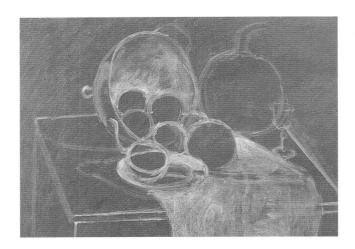

1 For this painting, add medium to all the colors. First, paint the red-violet cloth of the background with a mix of mineral violet and painting medium. The cloth provides an exciting color contrast to the fruit. When dry, draw the composition and block in the light areas with a mix of cerulean blue and titanium white.

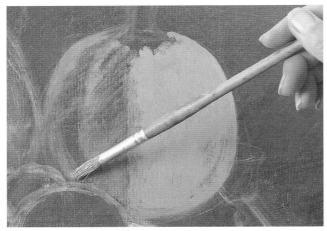

2 Establish the main colors early on. Paint the pumpkin with cadmium orange, applying the paint thickly on the right and thinly on the left, where the pumpkin is in shadow. The red-violet underpainting will show through the thinner paint, creating an impression of a shadow.

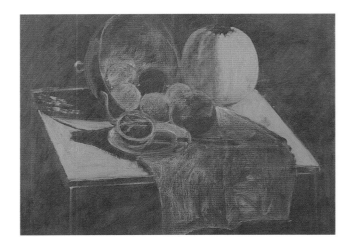

3 Apply yellow ochre to the pine box and the apples. Work around the cast shadows, leaving them as the red-violet underpainting for now. Also leave small areas of light from the holes in the cast shadow of the colander.

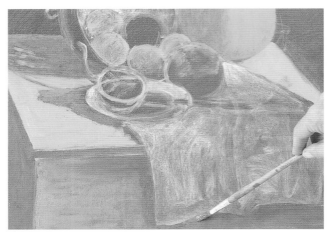

4 Paint the sides of the box with a mix of yellow ochre and a little monestial blue. Apply the paint thickly where the box is in the light, and drag the color on thinly where there are shadows. Paint the cast shadows with the same mix.

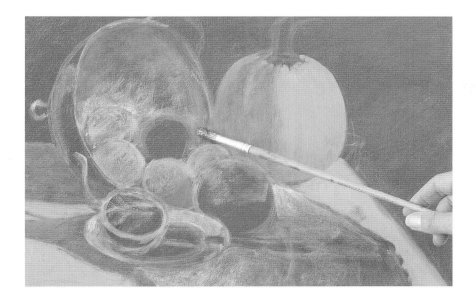

5 The inside of the colander reflects the various colors of the fruit. With a mix of yellow ochre and monestial blue, create a dull tertiary green and block in the reflected shapes.

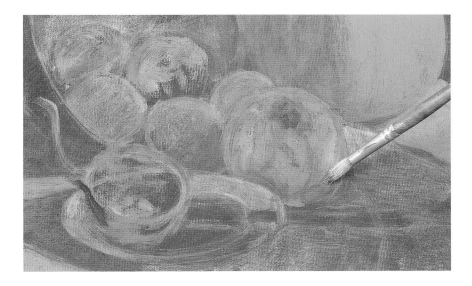

6 Paint the apple with a bright green mix of lemon yellow and monestial blue. Then paint the pomegranate in lemon yellow combined with carmine and titanium white. With the same color, suggest the pips on the cut half. Add touches of pure carmine to further define the shapes, working wet-into-wet.

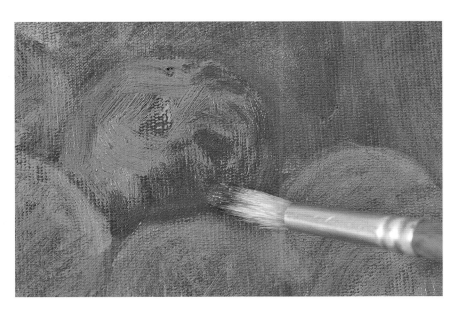

7 Let your brush strokes follow the curves of the rounded forms, such as the apple, to create a sense of volume. Then add a touch of carmine to give depth to the shadowed side.

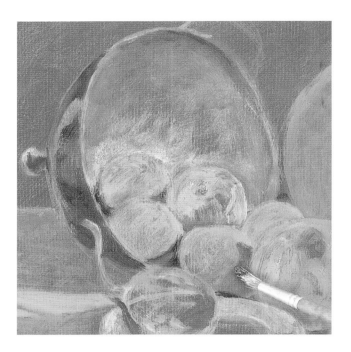

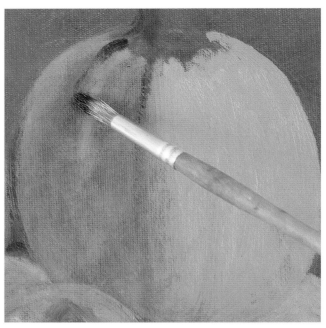

8 Working wet-into-wet, blend permanent mauve into the green of the apples to create shadows. Use the same color to paint the dark reflections on the back of the colander.

9 With the same color again, add touches of shadows to the pumpkin. The permanent mauve will blend with the cadmium orange to produce a dull green.

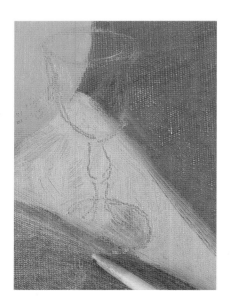

10 The original outline of the glass has been covered with paint, so use the handle of your brush to scratch in a rough outline.

11 With a mix of yellow ochre and white, draw the creases on the cloth. Follow these lines to block in the light and shadow on the cloth, where it falls over the edge of the box.

12 Paint the shadows on the plate and cloth with a mix of monestial blue, yellow ochre, and white. With a small touch of cadmium yellow mixed with titanium white, paint the lit side of the cloth. Drag less color on where you want the violet ground to show through, to create little shadows. Also, leave parts of the greenish mix to indicate shade.

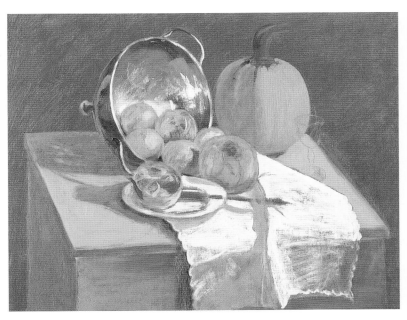

13 Use the warm white to develop shine on the colander, as well as the light on the plate and cloth and the moist highlights on the cut pomegranate. Don't make these highlights continuous blocks or lines of color; instead, suggest the reflection with a broken line.

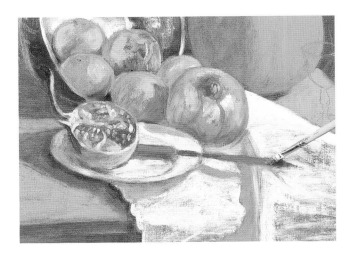

14 Paint the knife with a mix of cadmium orange, permanent mauve, and titanium white. Vary the tone to capture the shade and light on the handle and blade to give a three-dimensional solidity to the knife.

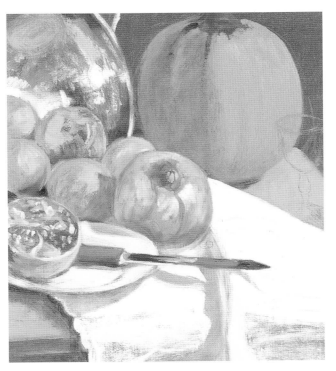

15 Using a mix of titanium white and cadmium yellow, work some more highlights into the cloth. This will strengthen the folds and make the knife look more solid in comparison.

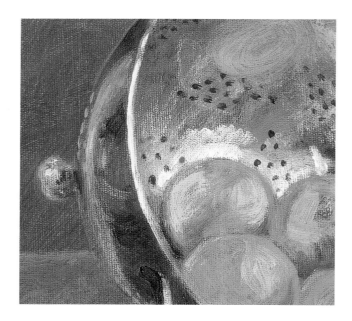

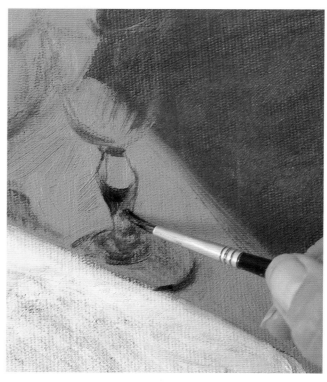

16 Using a rigger brush, stipple the holes into the colander with permanent mauve. You will find it difficult to draw the holes around the curved surface of the colander, so proceed carefully, but don't worry about making them perfectly precise. The impression of the colander will be enough. Once they are in, the colander is complete.

17 Following your scratched-in outline, paint the dark areas of the glass with a mix of permanent mauve and transparent gold ochre.

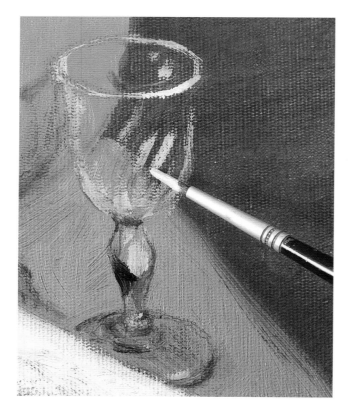

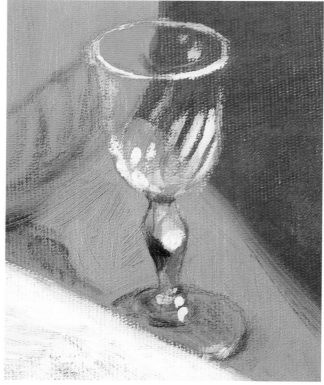

18 Add a touch of titanium white to the previous mix, and touch in the darker highlights.

19 Using a mix of yellow ochre and titanium white, paint the warmer highlights on the light side of the glass.

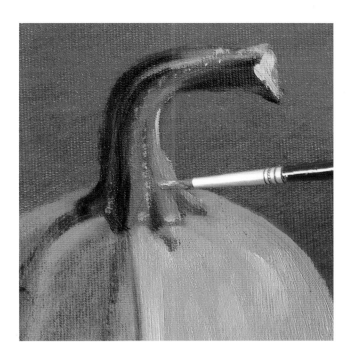

20 Paint the shadow side of the pumpkin stem with a mix of monestial blue and yellow ochre. Blend these into the cadmium orange and titanium white for the lit side. For the brighter highlights, use mineral violet and titanium white.

21 The finished painting is a balanced but lively composition, partly due to the complementary interaction of orange and yellow ochre with red-violet. Also, the knife adds a strong, straight edge to an otherwise curved and elliptical selection of objects.

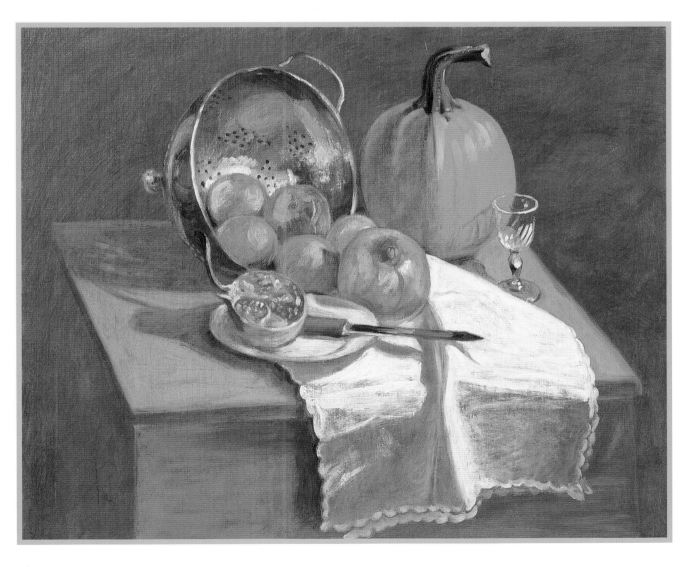

4
Developing landscapes and townscapes

The key to painting any subject is careful observation, and this is particularly true with landscapes and townscapes, whether you paint from life or from photo references. Many amateur painters work from photographs, and this can be a useful prelude to working out of doors, but it should not replace it entirely. If you work only from photographs, your landscapes and townscapes may not develop true vitality. It is only by accepting the challenges of changing light or weather conditions that we can "let ourselves go" and develop the natural quality of brushwork that is a result of real risk-taking.

If you are intimidated by painting outdoors, try starting off in a garden, before heading out into the country or on the street. A garden can offer intimate spaces to paint, which can be a useful first step toward the wide spaces of a landscape or the complexities of an urban environment.

Finding a composition that appeals from the mass of possibilities can be a problem. In the eighteenth century, it became popular among the middle classes to walk in the countryside, looking for the perfect composition in nature. Walkers would climb hills or mountains and inspect the view through a viewfinder, which could isolate a "picturesque" or "sublime" composition from the surrounding views, much as we do now with our cameras.

Painting is also largely about the organization of shapes, colors, and lines, and creating a perfect balance in a landscape painting can be a challenge. It is important to have a balance between the foreground, middle ground, and background. Applying atmospheric or aerial perspective; adding more detail to your foreground; establishing a center of interest, or focal point, are all ways of achieving this balance.

Creating the illusion of depth in a painting is an important aspect for both landscapes and townscapes. Buildings can be particularly challenging, especially if they are viewed in three-point perspective. However, following the rules of perspective (*see* page 25) will help you develop solid-looking structures that sit comfortably in your paintings. Use the techniques in this chapter, and draw on your knowledge of color and composition from previous chapters; then to go out and paint landscapes and townscapes to your heart's content.

How do I clearly define my foreground, middle ground, and background?

Obvious divisions of space in your subject—receding hill contours, overlapping elements, or strong contrasts in light or shade—will automatically separate the foreground, middle ground, and background. But some landscenes, such as seascapes, prairies, and deserts, may be so flat that it is hard to define the space in terms of these three divisions.

For the foreground, use a larger brush and bolder strokes to bring things forward. In the middle distance, use smaller brush strokes and merge individual marks into smoother planes. Take great care when comparing the scale of things in the foreground with objects farther away; a leaf nearby can be described with one brush stroke, whereas the same size mark in the distance could describe a whole hill. Also, make the foreground more detailed, and keep the details in the background to a minimum to help it recede into the distance. And remember that warm colors advance, and cool colors recede, so keep your warm tones in the foreground.

1 Start by applying a colored ground of yellow ochre mixed with titanium white. Then, sketch a rough outline of the landscape in raw umber. When this is dry, paint in the sky with a mix of titanium white and alizarin crimson.

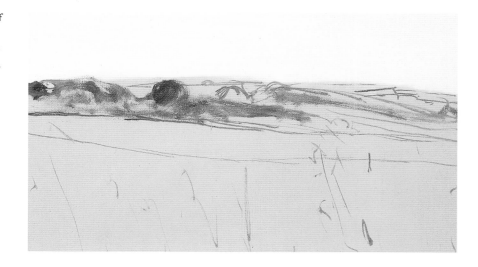

2 Develop the sky on the horizon using a deeper mix of titanium white and alizarin crimson. The glow of the alizarin crimson gives the impression of the sun setting behind the hills. Then block in the hills with a phthalocyanine blue mixed with titanium white and alizarin crimson.

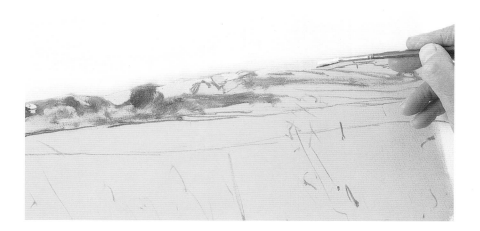

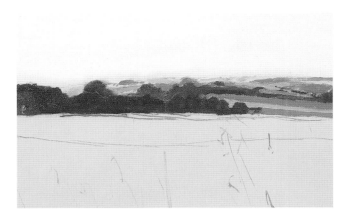

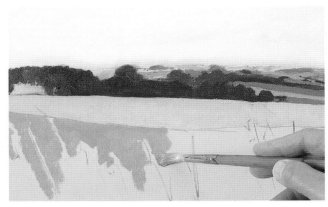

3 Develop the hills using the previous mix as a base but adding a medium green and phthalocyanine blue to make the blue hills seem farther away. Paint the trees in the middle distance using a mix of raw umber, green, and cobalt blue. The warmer, darker tones bring the trees forward into the middle distance.

4 Paint the field in the middle distance with a mix of yellow ochre, titanium white, and a touch of phthalocyanine blue. Use a higher proportion of yellow ochre to make a much warmer color for the field in the foreground. Paint carefully around the corn in the immediate foreground using a mix of yellow ochre, raw umber, and titanium white.

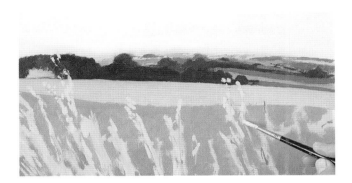

5 Highlight the wheat in the foreground with a pale mix of titanium white and phthalocyanine blue. Then paint the shadow detail with a mix of yellow ochre and raw umber. This detail will bring them forward in the picture.

6 To define the tall, ragged stalks of barley, paint the negative spaces between them. Then paint each stalk individually so they stand out from the landscape. This establishes a low viewpoint and intensifies the sense of distance.

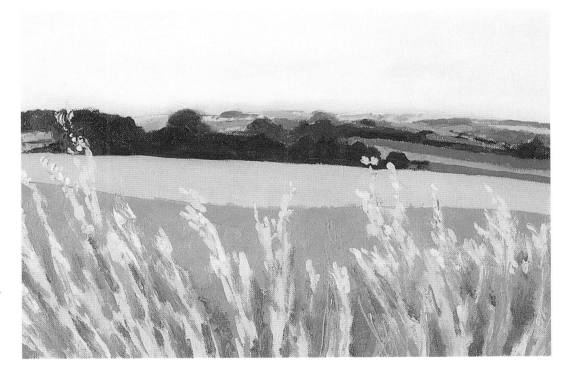

What is atmospheric, or aerial, perspective?

When you stand in front of a landscape that unfolds into the distance, you will notice that the colors closer to you are much stronger and the light and shade are more clearly defined than in the distance. This effect is *atmospheric*, or *aerial*, *perspective*. As light passes through the water vapor and dust particles in the atmosphere, the haze absorbs the warm end of the spectrum of light rays reflecting back off the hills, and so only the cooler, bluer rays are visible. Therefore, the colors in the distance tend to appear more blue, and the tonal values are much closer to each other and paler. A misty atmosphere creates an even more exaggerated effect.

Using the effects of aerial perspective in your painting enables you to create a sense of depth and distance in a landscape. In general, add more blue and white to your mix for distant objects. If there are warm colors in the distance, such as a hill covered with heather or a ploughed field, compare these with warm colors in the foreground, and mix in some cooler colors so the background still recedes and does not jump forward.

1 This painting of a range of hills shows how you can create an impression of space by fading and cooling the color mix for each receding hill.
Foreground: Use more yellow ochre in the mix to keep the colors warmer. **Middle ground:** Reduce the quantity of yellow ochre and add more monestial blue and titanium white.
Background: Use almost no yellow ochre, if any—just monestial blue and titanium white. Although the hills are simply cutout silhouettes, adjusting the color mix for each hill suggests a sense of distance.

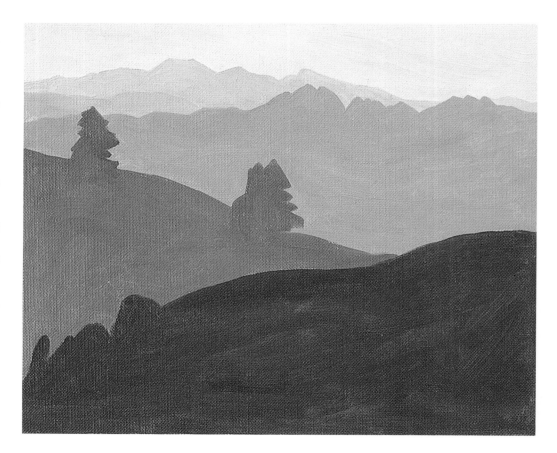

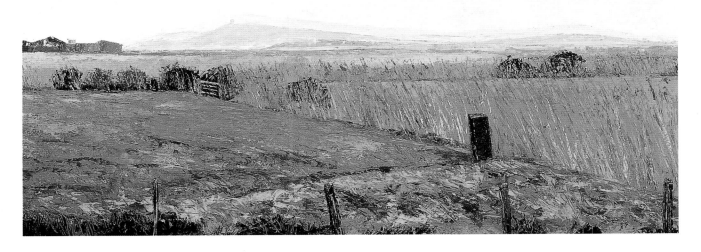

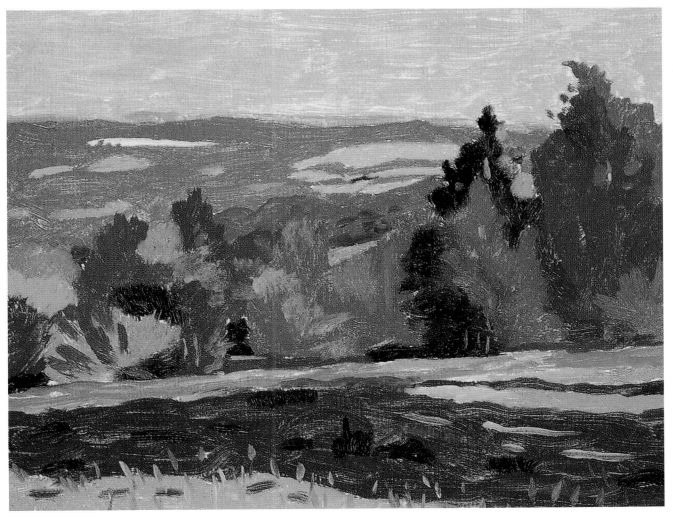

Top: In this painting by Rosalind Cuthbert, the effect of aerial perspective is clear. As the hills recede, the colors become cooler and bluer, giving the impression of distance.

Bottom: The foreground of this picture by Jeremy Galton is painted with warm colors, bringing it forward in comparison to the cool hills in the distance.

What is atmospheric, or aerial, perspective?　　**79**

How can I paint realistic clouds?

Clouds come in many shapes, colors, and sizes. As with painting everything, observation is the key, but the methods you employ will depend on the type of clouds you are painting. Cirrus clouds can be stippled into wet paint, whereas large cumulus clouds will require rougher and more textured brushwork. The colors of your clouds will vary according to the weather and the time of day— darker tones for rainy weather and late afternoon and evening, and paler hues for clear, sunny days and morning and early afternoon.

For cirrus clouds, first paint the sky with a mix of cerulean blue and titanium white. While it is still wet, dab white paint onto your paper in a circular motion, copying the pattern of the clouds. Let the two colors merge together, creating a soft, slightly out-of-focus effect.

Larger cumulus clouds require a slightly different approach. First, paint the negative spaces of the sky with a mix of blue and white, leaving a rough shape of the cloud unpainted. Then block in the cloud with titanium white, blending the edges into the blue of the sky as you work. Add some shadow to the bottom of the cloud with a mix of monestial blue, titanium white, and cadmium orange.

With stratus clouds, much less sky is visible. First, paint the negative spaces of the blue sky with a mix of ultramarine blue and titanium white. Then paint the general cloud shape with titanium white, and roughly blend in the shadow color with a mix of titanium white, yellow ochre, and a touch of alizarin crimson. Apply the paint with horizontal strokes to suggest wind.

Above: In this painting, Brian Bennett has painted clouds roughly with a painting knife to give a stormy effect. Bands of light and shadow just above the horizon give a sense of the storm passing by.

Below: In this painting by Arthur Maderson, an unusual effect is visible: the nearest cloud is painted in cooler shades than the distant ones—following the rules of atmospheric perspective.

How can I create a create a sense of distance with trees and foliage?

Detail—or lack of it—is the secret to painting foliage to give a sense of receding trees. Paint the trees closest to you with the most detail; paint those farthest away with mere suggestions of form and color. To help create the impression of distance, make the trees and other foliage in the background smaller in size as compared to the elements in the foreground.

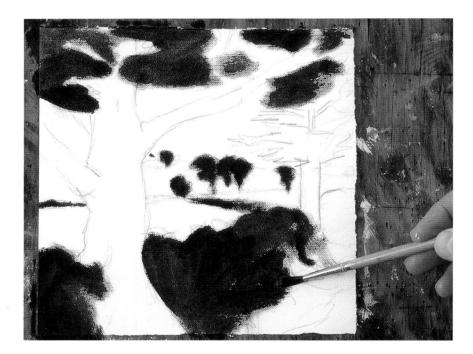

1 First sketch your composition in pencil, noting that the trees closest to you will be only partly visible because they are so large, whereas trees farther away will be tiny in comparison. Block in your first color with a mix of Hooker's green and burnt umber. (Because they are much farther away, the trees in the distance will consist only of this color.)

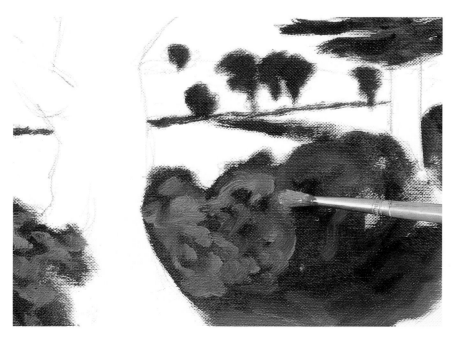

2 Add more detail to the foliage in the foreground with a mix of zinc yellow, Hooker's green, and burnt umber. Apply only subtle touches of the light green to the foliage as it gets farther away. This will give the impression that it is receding.

3 Use the same light green to paint some lighter-colored foliage on the two closest trees. The foliage on the second tree should be less detailed because it is farther away. Add some zinc yellow to the light green mix to paint the fields. This color, and versions of it, will link all the different areas of the picture.

4 Apply a smooth underpainting to the tree trunks with a mix of red-violet, translucent gold ochre, and titanium white. Even though the palette in this example is restricted, there is still a strong sense of recession, created by the reduction in size of the objects as they recede in the picture plane.

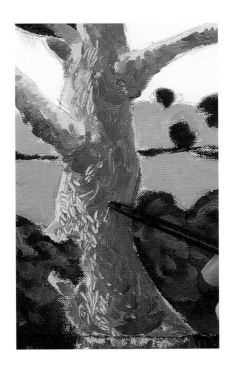

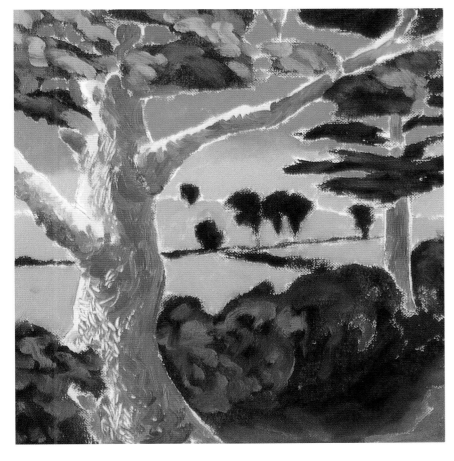

5 Use a hog brush to loosely apply a mix of burnt umber, translucent gold ochre, and red-violet to the tree trunks. Then scratch through the paint layer with the handle of your paintbrush to reveal the lighter color beneath. This detail brings the tree forward in the landscape.

6 Lessening the detail of the trees and the bushes farther back in the picture plane helps give an impression of distance.

How can I create the impression of a landscape shrouded in fog?

Fog casts a soft focus over an entire landscape; only the very closest objects have any definition at all. In the middle distance, objects appear pale; but farther into the distance, tonal contrasts diminish further, and everything takes on the gray silhouette characteristic of fog. To create this hazy effect, blend all the colors of your landscape together.

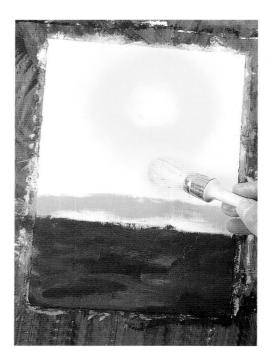

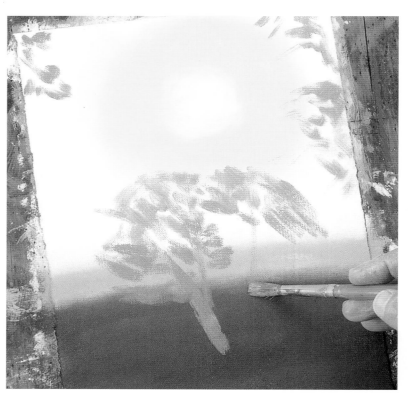

1 First, paint a generous layer of a mid-tone color onto primed paper. Then, apply a mix of titanium white and a little permanent mauve for the sky. Below this, paint a band of phthalocyanine green mixed with titanium white for the middle ground. Apply the final color with a mix of permanent mauve and a little white for the foreground. At this stage, the colors look quite bold, but this will change once you blend in the paler tints. Next paint the sun with lemon yellow and use a round decorator's brush to gently blend it into the pale mauve of the sky.

2 Still using the decorator's brush, blend the three bands of color together so they look slightly blurred. Then, using a round hog brush, paint the focus of the painting—here, the tree— with a mix of white and permanent mauve.

3 Suggest fallen leaves by making broad sweeps of the brush using a mix of cadmium orange and alizarin crimson.

4 Next, use a medium round sable brush to add fine detail to the tree with a dark mix of phthalocyanine green, permanent mauve, and titanium white. With the light-colored sun behind it, this color will appear very dark.

5 Blend and stroke a mix of titanium white and violet into the wet paint where a softer focus is needed. Add pockets of mist on the ground, so the mist looks as though it is creeping forward.

Left: In this painting by Derek Mynott, delicate, calligraphic line work over a layer of softly scumbled pale blues and yellows creates an impression of light penetrating the mist and illuminating the foreground.

How can I create the impression of a landscape shrouded in fog?

Demonstration: **Outdoor landscape**

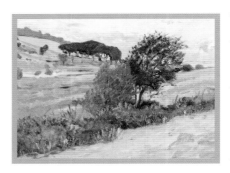

The pleasure of painting in the open air inspires many people to take up painting. However, the first time you paint outside, it will probably feel quite strange. There are so many possible subjects to choose from that the experience can be confusing, and even a little daunting. It is a good idea to first develop your drawing and painting skills indoors, learning to observe closely and to create compositions of interesting still life arrangements. Next, try painting in your garden and neighborhood, where you can choose a small corner to start with and gradually increase the complexity of your compositions as you gain confidence.

EQUIPMENT FOR PAINTING OUTDOORS

- A light, tubular steel or wooden easel
- A light folding chair or stool
- A light canvas bag or knapsack
- A few selected tubes of paint. You can buy small tubes, which are easier to carry. Suggested colors: titanium white, lemon yellow, cadmium yellow, yellow ochre, cadmium red, alizarin crimson, ultramarine, cerulean blue, viridian, Hooker's green, burnt umber, and raw umber. You can mix most colors from just these few and add or remove colors as your own preferences develop.
- A few small painting boards or an oil sketchbook (try this on your easel first)
- A small palette
- A dipper
- A small bottle of pure turpentine
- A small bottle of mineral spirits
- Painting medium
- A cotton rag
- A few hog bristle brushes
- Think about a means of carrying your wet paintings; some shallow cardboard boxes can be useful. Some artists make their own carrying cases to fit a certain size of painting board. Whatever you use should be light enough and small enough to carry along with the rest of your equipment.
- You should be able to fit everything into a backpack, leaving your hands free for the easel and stool. Some artists do without an easel, finding it convenient to work on their laps.

This list may not be perfect for you, but it will give you a good starting point. After a few forays, you will discover what you can leave behind or what else you might need.

1 Once you have set up your easel, use a viewfinder to scan the area around you for an interesting composition. You can adjust the viewfinder to a square, portrait, or panoramic (landscape) format.

2 Take your time selecting an interesting composition. Make sure that it is not only visually interesting but also balanced in terms of tone and color.

3 Begin by sketching your composition in lemon yellow, using a fairly large round hog brush. Lemon yellow is easily incorporated into subsequent layers of paint and gives the painting a feeling of sunlight from the outset. Thin the paint with a little turpentine, and add painting medium to speed up the drying process. (Add painting medium to all the colors).

4 Once you have established the composition, paint over the strongest lines of the landscape with monestial blue. Then block in the dark areas with the same color.

5 Block in the grassy areas by adding touches of crimson lake, monestial blue, and yellow ochre to the lemon yellow. Keep the paint thinned with turpentine and painting medium. Make broad, flowing sweeps with a large flat hog brush.

6 At this stage you have established the main areas of light and shadow and have a strong base to work on.

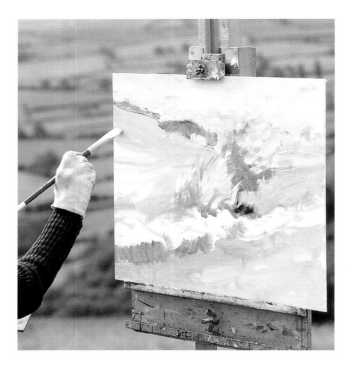

7 Working quickly, paint the sky with a thinned mix of monestial blue and crimson lake.

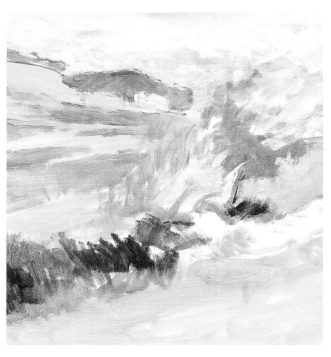

8 Paint the sky early so that you can paint foliage on top of it. It is not impossible, but it is more difficult to paint expanses of color around detailed objects.

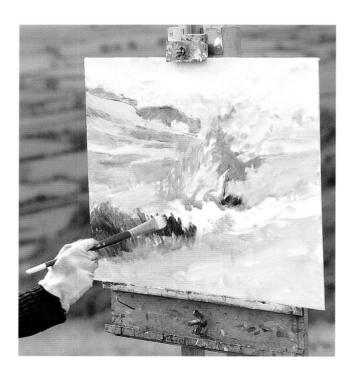

9 Next, add some Hooker's green and viridian—pale in the middle distance and much darker in the foreground. Add impasto medium to bulk out the paint, and make your brush strokes more obvious from now on.

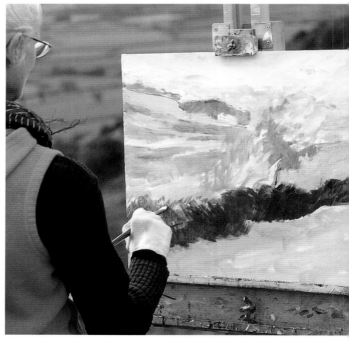

10 Paint the dark green bushes in the foreground using short, brisk brush strokes to capture the details and texture of foliage. Keep the brushwork lively by painting quickly.

11 Next, use a mix of monestial blue and a little alizarin crimson to darken the foliage of the trees.

12 Mix together several colors—yellow ochre, a bit of viridian, cadmium red deep, and titanium white— to make the warm browns of the bracken and the small bushes.

13 Hint at the undergrowth on the hills in the middle distance with little flicks of the brush.

14 Use monestial blue to paint the trunks of the large group of trees in the distance.

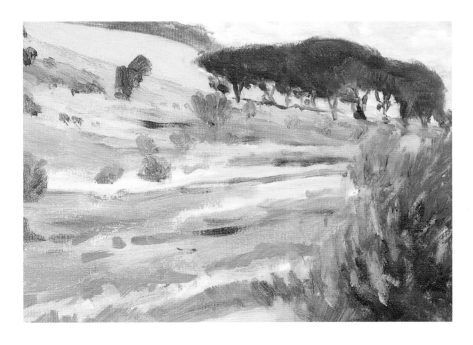

15 Mix a pale mauve from some monestial blue, alizarin crimson, and titanium white. Use this color to block in the distant wall and add details to the main tree.

Demonstration: Outdoor landscape **89**

16 Lighten the outer foliage on the trees in the middle distance with cadmium yellow deep mixed with white.

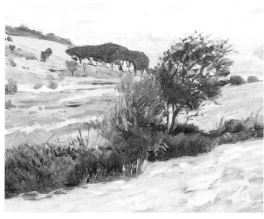

17 The foreground and middle ground are almost complete, but there are still details to finalize.

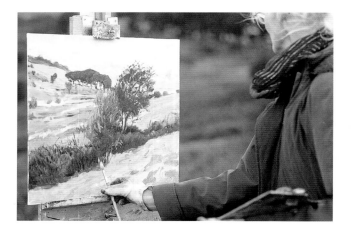

18 Using white warmed with a little yellow ochre, paint some dried grasses using the tip of a round brush. Add color to the immediate foreground in broken horizontal strokes.

19 Add more dried grasses with the edge of your painting knife. Include impasto medium in the mixes to help build up the paint surface.

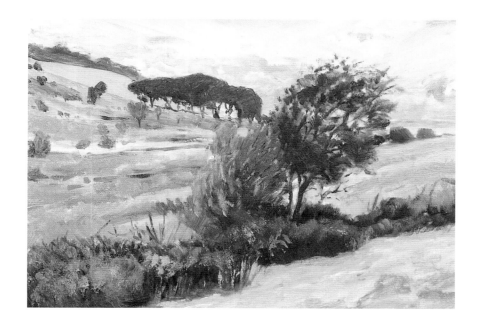

20 Stand back from your painting to take a fresh look at it. Although it is nearly complete, you may still like to add a few small touches.

21 The nearest tree needs a little more color. Load your brush with cerulean blue, and dab it into the darker blues with short, light brush strokes. This will make it contrast more with the reddish bush nearby.

22 Look at your painting again to decide if there are any areas where you think distinct colors should be blended. Blend colors on the board using a clean brush.

23 Scumble on some cadmium yellow for the flowers.

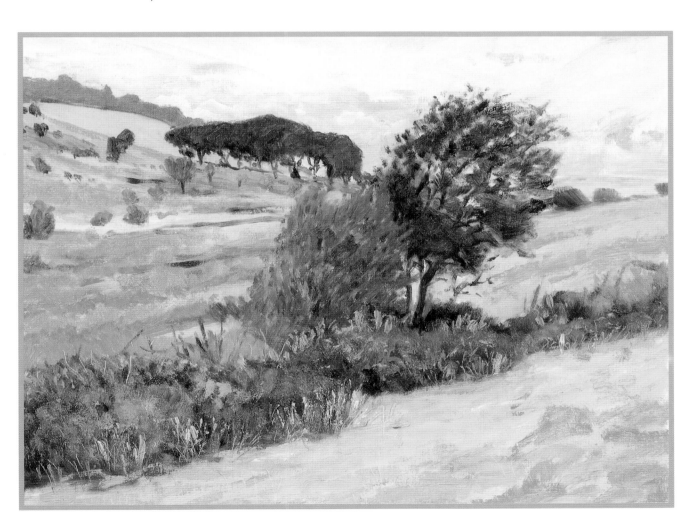

24 When working out of doors, the light changes through the course of the day, sometimes quite quickly and dramatically. A quick color sketch at the outset can help you to complete your final painting.

The windows I paint are either stark black holes or seem to disappear into the walls. How can I paint realistic windows?

A window presents a particular challenge to an artist who is interested in architectural subjects. It might reflect the sky or objects nearby; it might protrude or be recessed; it might be decorated with stone, wooden, or metal details, such as shutters; it might even allow you to glimpse the curtains or the room inside. The most important thing a window adds to a building is a feeling of atmosphere. You can make the viewer believe that a building is a safe, warm place or a derelict, forgotten structure just by the way the windows are portrayed.

Remember to relate each window both to the others and to the shape of the building as a whole. Look for cast shadows to give each a sense of solidity, and carefully observe the reflections in the glass to describe the light and conditions of the rest of the scene.

1 Sketch a window in pencil, and then block in the main surrounding colors.

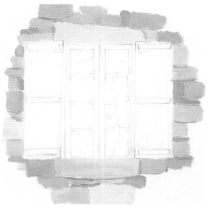

2 Pick out some of the details of the brick or stonework around the window, like these large stones in several shades of gold ochre and titanium white. Then, paint the mortar with a darker tint of the same colors. These will be your base colors for the frame and shutters.

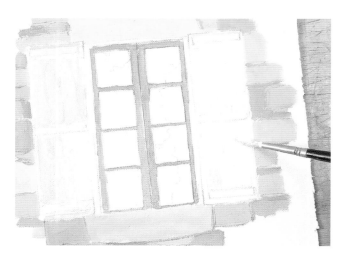

3 Give the window frame an underpainting of gold ochre. Then, paint in the shutters, blocking in the color to offset the windows.

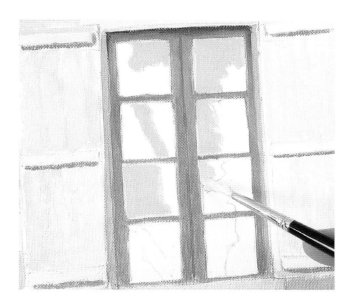

4 Add shading to the window frames with a mix of burnt umber and ivory black to give the wood a three-dimensional look. Apply the lighter areas of reflection in the glass panes with a mix of cobalt blue and titanium white.

5 Paint the dark areas of reflection in the glass with a mix of ultramarine, ivory black, and titanium white. Then, paint the lightest areas by blending titanium white into the other colors.

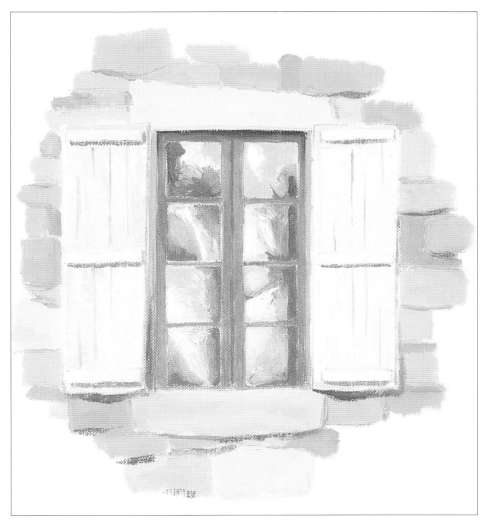

6 Shade areas of the brickwork with a mix of burnt umber and ivory black to define the shape and depth of the bricks. For the final touch, paint the shadows cast onto the wall by the shutters. The reflections in the finished piece show the abstract patterns that light often casts on glass.

The windows I paint are either stark black holes or merge into the walls. How can I paint realistic windows?

Demonstration: A view of a French church

Sometimes you will come across buildings that are so large that they sit both above and below eye level in a composition. This type of subject is a challenge for students of perspective (*see* page 25), but can be used to create very striking paintings.

Old buildings often have a lot of fine architectural detail, but remember that it is not necessary to paint everything you see.

You can suggest details with just a few brush strokes, and close observation of shadows and highlights will help you to capture the solid and three-dimensional nature of the building you are painting.

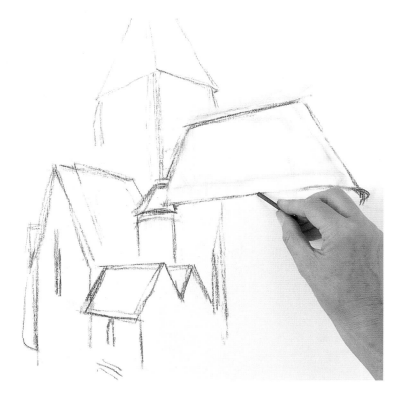

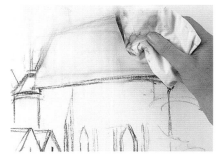

2 Before you paint, gently dust the charcoal drawing with a cloth to remove any loose particles. You will still be able to see the drawing, but the charcoal won't dirty the paint.

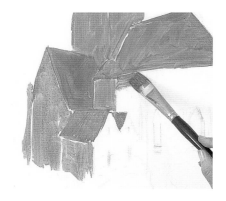

1 A large, closeup building that sits both above and below the eye line is difficult to draw, so use thin charcoal that you can erase if you need to make a correction. (Press gently because thin charcoal is brittle). Position the church in the right of the picture plane in order to leave space for the large tree on the left; this will also help set the building back a little in the picture field. Observe all the shapes and angles carefully to ensure that your perspective is correct.

3 Block in the main shapes of the church in light red mixed with some turpentine and painting medium. Vary the transparency of the paint with different amounts of turpentine and medium to keep the underdrawing of the roofs and walls visible.

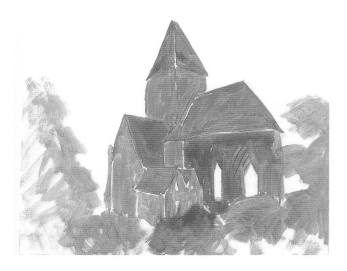

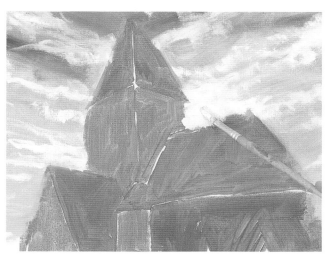

4 Leave the windows white for now, so you can see them clearly. Then apply light red as an underpainting for the trees.

5 Before defining the building further, paint the sky with a mix of cobalt blue and titanium white. Then scumble titanium white into the blue layer to suggest clouds.

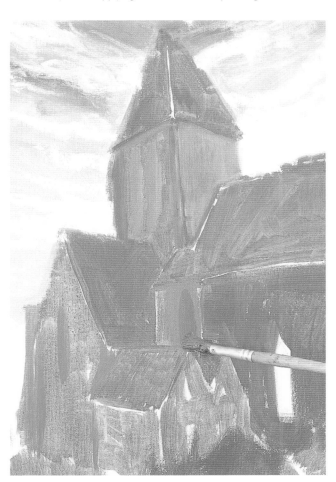

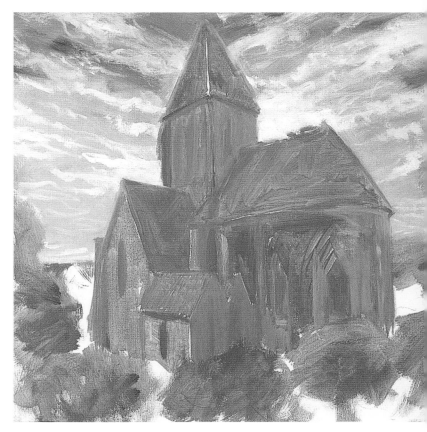

6 Define the light and shade on the stone walls to delineate the basic form of the building. Mix cobalt blue, cadmium orange, and titanium white, and block in the shadows of walls and window openings.

7 At this stage, the picture will look quite rough because it is mostly underpainting, but you will nevertheless have a sense of the developing structure.

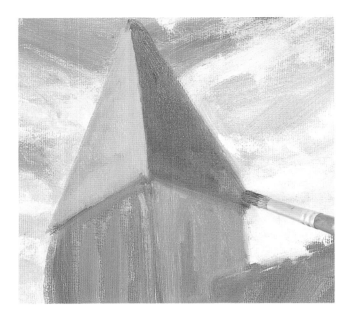

8 Add some light and shadow to the slate spire using a mix of ultramarine, cadmium red deep, and titanium white. Vary the tone and apply more white where the sunlight bounces off the slate.

9 Mix some yellow ochre, alizarin crimson, and titanium white and paint the pale stone walls on the sunlit side of the church. Make the paint a buttery consistency, and apply it rather thickly. Carefully paint around the windows to preserve the perspective that you captured in your charcoal line drawing.

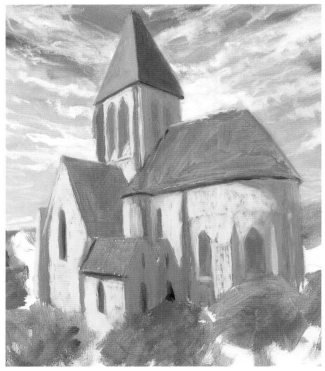

10 You can see when you block in the color on the church that the light red underpainting imparts extra warmth to the color on top.

11 By establishing the basic areas of light and shadow, you give the whole scene a sense of structure and make the building look solid.

12 Next, use cadmium red to paint the shadow areas of the roof. Apply the paint roughly to give the roof texture.

13 On the sunlit side of the roof, the color is warmer. Mix a new tint with cadmium yellow deep and cadmium red, and scumble it over the underpainting to create the impression of tiles. With the side of a long flat hog brush, add extra details to the top of the roof.

14 Give the trees in the foreground a few brushloads of Hooker's green deep with a decorator's brush, which is ideal for loose scumbling. The green layer should be loose enough to show the underpainting here and there.

15 Before you add anything more to the trees, complete the finishing touches to the building. Notice that the sun is catching various surfaces and details. Mix a highlight color with a little cadmium yellow deep and yellow ochre added to titanium white, and add just a few touches to the roofline.

16 Use a fine sable brush to add some lighter details to the gray slates on the spire. These pale slates are a decorative feature of the tower.

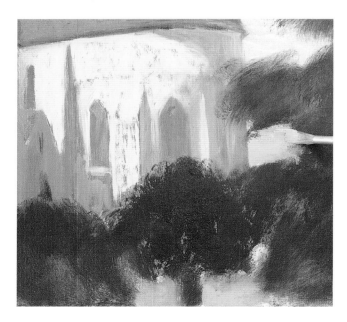

17 Apply a mix of cadmium yellow and titanium white between the foliage and the wall to create a striking contrast.

18 Using a long, flat hog brush, add some more light to the walls to show reflections of sunlight.

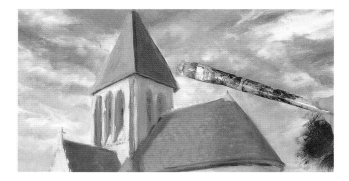

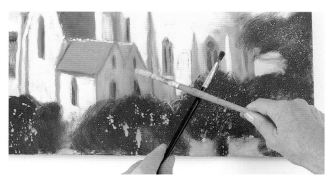

19 Add some final touches of cobalt blue mixed with titanium white to the sky around the spire. This will help to define the spire against the sky.

20 For a final touch, add some further texture to the trees with a mix of lemon yellow and titanium white. Load a brush with the mix and spatter it onto the trees by tapping your brush against another. Be careful not to spatter the building.

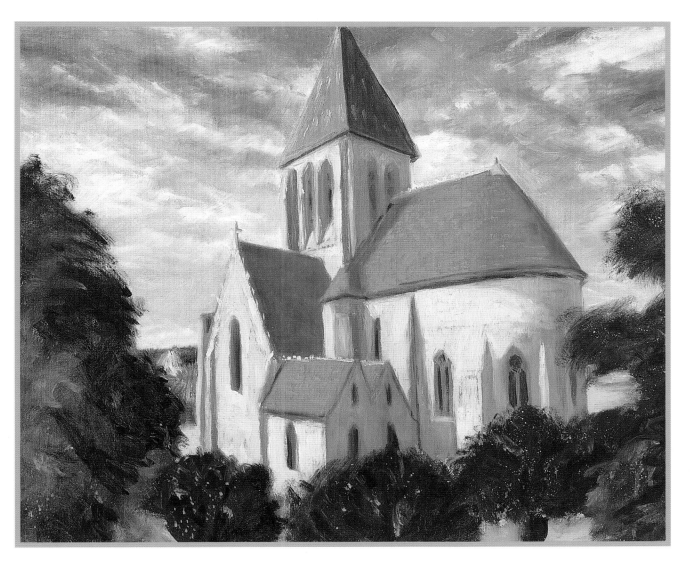

21 To complete the trees, scumble them with a mix of ultramarine and light red. Then use a small flat sable to add patterning to the slate roof.

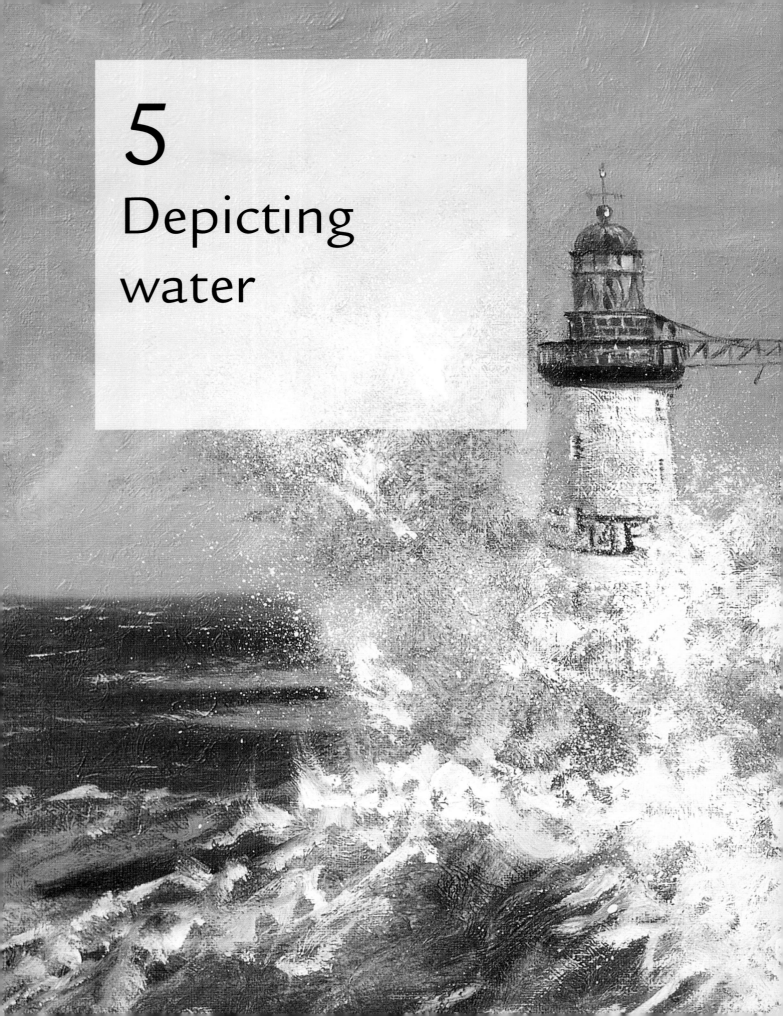

5
Depicting water

Making opaque paint resemble a liquid may seem to be a challenging task; but—surprisingly—water is easier to paint with oils than with watercolors because there are so many techniques that can be used. As you will discover in this chapter, the key to painting water—whether it's a waterfall in constant agitated movement, a choppy sea, or a still lake with mirrorlike reflections—is observing the essential features. These features include the main colors and tones, the patterns made by ripples and the direction in which they move, and the shapes of waves and the way they curl over the top, showing the dark underside below the white crest.

Possibly the most expansive of subjects to try to paint is a view across an ocean. Its form is constantly changing, especially with rough seas. Many artists work from photographs so they can spend time catching the true character and shape of the waves. The English painter L. S. Lowry attempted to paint the sea's grand simplicity in his *Seascape* (1950). On a predominantly white canvas, small waves ordered in rows recede back from the bottom of the canvas toward a faint horizon, almost invisible through a light mist. High above, the whiteness of the sky gives way to a streak of blue-black cloud, making the painting strangely abstract and ethereal. Another unearthly sea appears behind *The Birth of Venus*; but in Raphael's vision, it is a heavenly blue expanse decorated with little wavelets.

Painting rivers, streams, and lakes can present challenges as well. Still water can contain complicated reflections that are disturbed and distorted by ripples. However, this chapter will help you overcome these difficulties, giving you advice on how to sketch these complicated forms, how to manipulate color to create waves and reflections, and which brush techniques to use to create both rough seas and reflections.

How can I make still water look clear but not invisible?

The key to painting clear, shallow water is being able to capture the distorted objects below its surface. Because the objects are wet, they look darker; and, as the water deepens, they take on a bluish or greenish color cast.

1 Mix cobalt blue, titanium white, and painting medium to create a warm, blue-colored ground. Draw the outlines with ultramarine mixed with carmine.

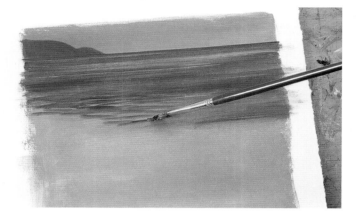

2 Paint the sky with a mix of cerulean blue and white. Block in the distant peninsula, and darken the distant water with ultramarine blue.

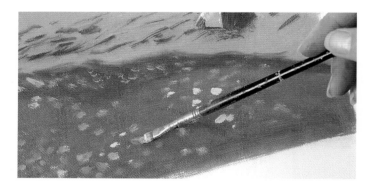

3 Use the same color in the foreground to darken the foreshore and indicate the water's edge.

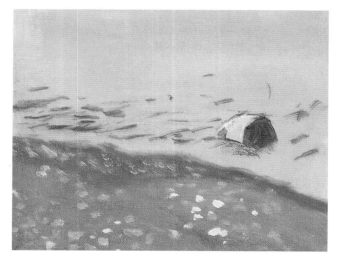

4 Paint the pebbles on the shore in varying tones of cerulean blue, titanium white, and yellow ochre. The sharpness of the pebbles on the shoreline will form a contrast to the blurred pebbles under the sea.

5 Mix lemon yellow and emerald green to paint the seaweed. For the water's edge, mix cerulean blue with some titanium white, and paint some of the dry pebbles on land with titanium white.

6 Use cerulean blue, titanium white, and emerald green in varying mixes to paint the sea, giving the impression of the water deepening farther back. Suggest clumps of seaweed using the same mixes.

7 Develop the impression of sunlight on the dry pebbles in the foreground with strokes of titanium white and touches of cerulean blue and yellow ochre. In the shallows, add more cerulean blue to suggest some pebbles beneath the water, but blur and distort these with your brush. Also, tone down the seaweed slightly with touches of blue to give the impression that it is underwater. Then add a bit of ultramarine to break up the water's edge.

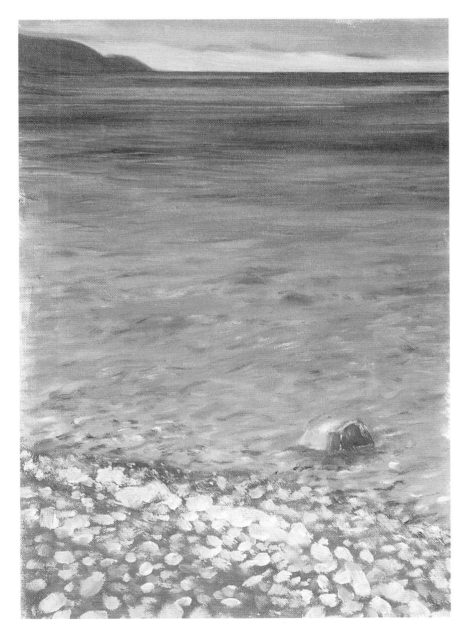

How can I make still water look clear but not invisible? **103**

How do I make reflections on water look different from the objects themselves?

Water usually reflects whatever surrounds it. Reflected colors are a little darker than their source colors, and, if the water is muddy, this too has an effect. The type of light also affects reflections. For example, sunlight bounces off ripples breaking up the colors and shapes of any objects reflected in the water.

A cloudy day, on the other hand, makes reflected colors seem much darker, and the calmer the water, the more perfect the reflection. Reflections in still water seem to drift downward and become slightly elongated; ripples on water disturb reflections, distorting the object's shape and outline.

Observe whether horizontal ripples are all you need, or whether you also need vertical lines. If so, place the vertical lines first and then develop the water surface with horizontal strokes for any further ripples.

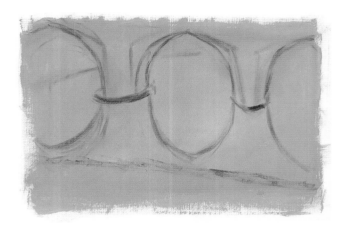

1 For this bridge in late afternoon light, first paint a ground of warm, earth-red—with a mix of titanium white, a little light red, and painting medium. Make a quick sketch of the bridge using sepia.

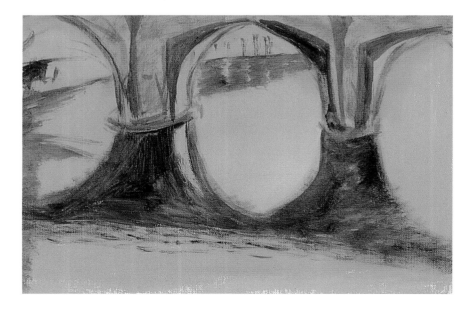

2 Add the dark reflections cast by the bridge on the water, and the architectural details with a mix of sepia and painting medium to complete the underpainting.

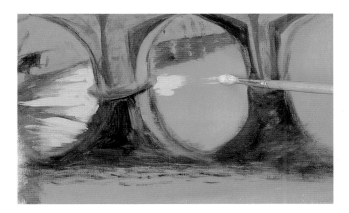

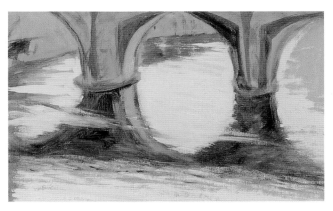

3 Paint the bridge using a warm mix of cadmium orange, titanium white, and burnt sienna. For the water, start with a cool blue, painting in wavy, horizontal strokes with a mix of cerulean blue, transparent gold ochre, and titanium white.

4 The ripples define the surface of the water, so cut across the dark reflection of the bridge to imply a sense of movement. Also add some warm tints to the reflection of the bridge's masonry with a mix of cadmium orange, titanium white, and burnt sienna.

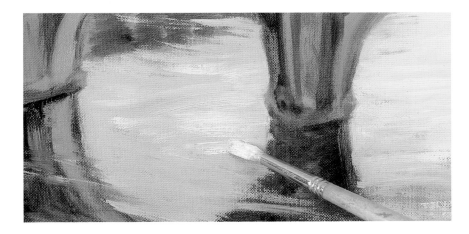

5 Give a golden glow to the river with horizontal strokes of a mix of cadmium yellow and titanium white. Further define and soften the outlines of the bridge's reflection to create the impression of moving water.

6 Paint the front of the bridge, which is in shadow, with a mix of cerulean blue, burnt sienna, and white. Leave the inside of the arches the warm tone applied earlier to capture the light shining from behind. Add a few strokes of the same color where it is visible in the dark reflection.

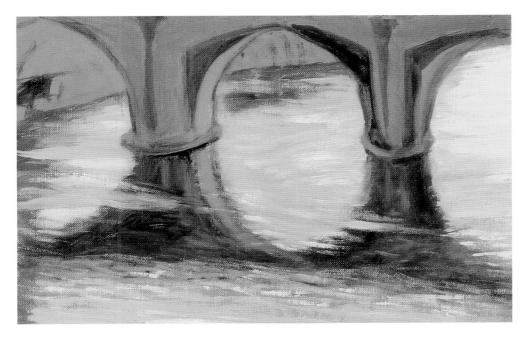

Beach scenes are among the most popular subjects for oil paintings. Umbrellas, towels, and all the paraphernalia of beach games provide endless opportunities for creating interesting compositions. People sunbathing and swimming, and children playing become models for studying the human figure. And the sea itself—expansive and glittering, swept into mountainous breakers, or lying gray and quiet beneath a blanket of clouds—is an enthralling and challenging subject.

2 Turn the canvas the right way up and carefully draw the yachts with ultramarine lightened with a little titanium white. Use a mahl stick if you feel you do not have a steady hand; it is important to keep the background colors clean.

1 Start by painting parallel stripes of color to represent the sky, sea, and beach. To make it easier, turn the canvas sideways so you can paint using vertical strokes of the brush rather than horizontal ones. Paint the sky with a mix of ultramarine, permanent mauve, and titanium white. For the sea, use monestial blue with a little permanent mauve and white. Lighten and warm this mix as you come forward in the picture by adding more yellow ochre and white. Blend these two tints together to suggest deep and shallow water. For the wet sand, use yellow ochre mixed with cadmium orange and permanent mauve. For the dry sand in the immediate foreground, use a mix of yellow ochre, titanium white, and a touch of permanent mauve.

3 Turn the canvas on its side again and paint the foreground puddles with a mix of ultramarine, titanium white, and a touch of cadmium orange.

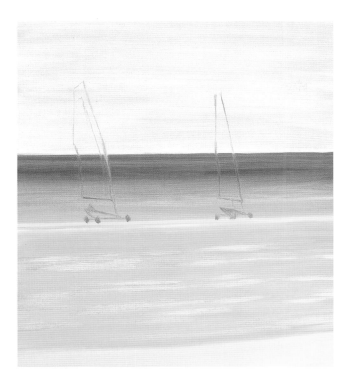

4 Turn the canvas and apply a paler mix of titanium white and ultramarine on the puddles to create the impression of light reflecting off their surface.

5 Make the wet sand darker with a layer of yellow ochre mixed with permanent mauve. Look carefully at the puddles to judge the tones correctly so they seem to shine.

6 Finish the sea before you start to work on the sails of the sand yachts. Paint the wave crests using titanium white.

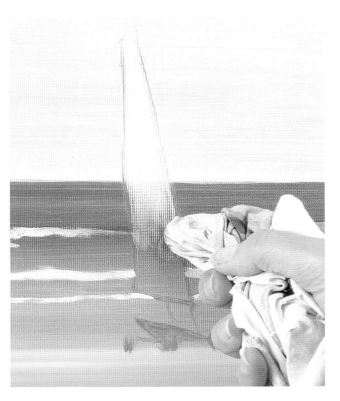

7 Before you paint the sails, wipe away the underpainting of the sea and sand with a clean rag.

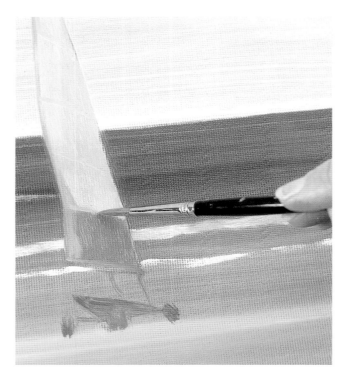

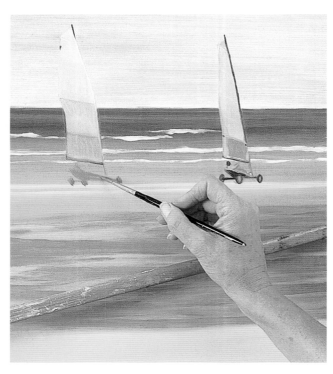

8 Paint the sails in varying tones of cerulean blue and titanium white, with the darkest tone at the bottom and the lightest shade at the top. Apply cadmium yellow for the yellow borders on the sail.

9 Carefully add details to the yachts, using a mahl stick to steady your hand if necessary. Paint the buggy and wheels of the sand yacht on the right in a mix of ultramarine and permanent mauve. For the sand yacht on the left, use a slightly paler tint of yellow ochre with permanent mauve and titanium white.

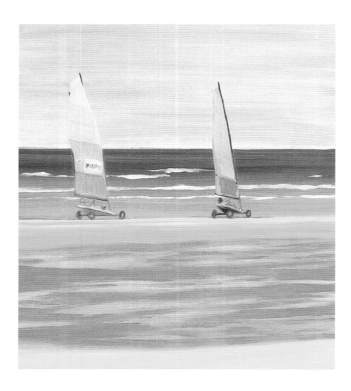

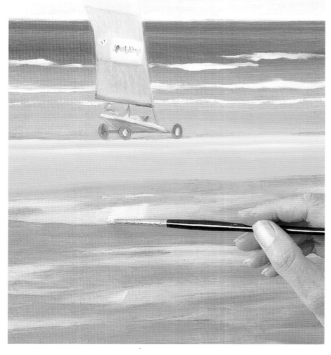

10 Paint the driver's helmet with cadmium yellow. With the yachts completed, start to add the reflections to the puddles on the sand.

11 Look closely to get the correct angles for the reflections, or they will look unrealistic. Use a mix of cerulean blue and titanium white, keeping the outlines soft and slightly out of focus.

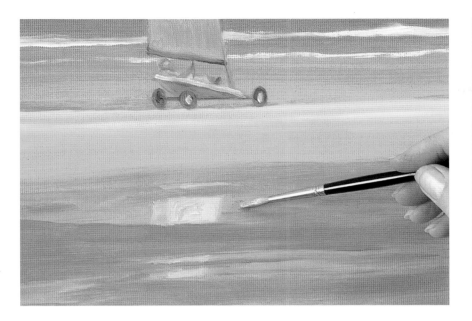

12 Darken the color of the puddle alongside the reflections with a mix of cadmium orange, permanent mauve, and titanium white. Be careful not to misjudge the color relationships, or the effect of the reflections will be lost.

13 Add some darker color values under the sand yachts and around the puddles with a mix of cadmium orange and permanent mauve. This will highlight the puddles and reflections.

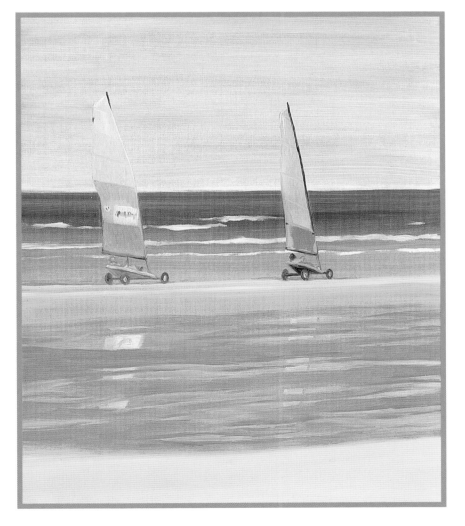

14 It is possible, as you can see here, to convey a windy day, without resorting to depicting racing clouds. Also, the tonal variation of the wet sand and shallow water makes it appear as if the tide is going out.

How do I paint running water, as distinguished from still water?

The play of light on water pouring from a faucet, cascading over a cliff as a waterfall, or trickling over rocks in a small stream may seem to be an impossible subject to paint. The first step in such a painting is building the context in which this is taking place—drawing the rocks, the stream edge, the gorge, or the kitchen sink.

Although it may be clear, water is certainly not invisible because it has mass. Light catches patterns of movement on water, and this is what you need to re-create. Spend quite a while simply looking. Before long, you will recognize the patterns of flow as they repeat themselves. Paint the darker color patterns first, leaving areas as they are where the water appears translucent. Observe where the light catches the water, and gradually build up the highlights. For example, in the painting below, some of the sink is still visible through the water.

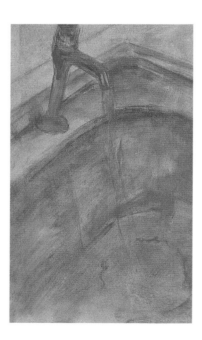

2 Use a slightly paler mix of the outline color to add depth to the faucet and sink. Then add a few touches of darker brown to the faucet and drain.

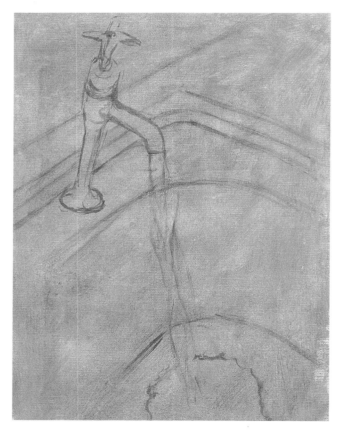

1 Paint a tinted ground with a mix of cobalt blue and raw umber, thinned with painting medium. Sketch the outline with a darker mix of the same colors.

3 To create the metallic color of the sink, add cerulean blue, raw sienna, and a little white to the previous mix, and paint it roughly over the initial underpainting.

4 Next, mix a paler and more opaque color of cerulean blue, raw sienna, and titanium white to define the reflections on the faucet, sink, and water. Add more white to the mix to create sparkle in the water. Keep the brush moving to give the marks a fresh and spontaneous quality.

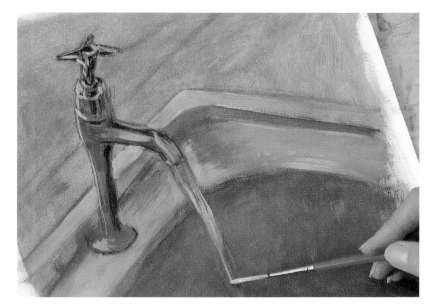

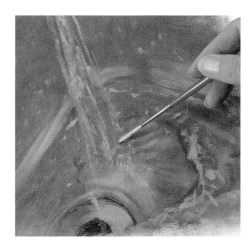

5 Paint the warmer reflections on the sink with a mix of yellow ochre and titanium white.

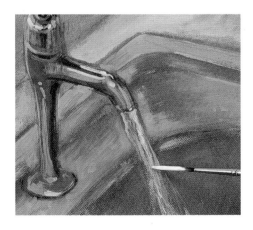

6 With a rigger brush, paint the reflections using a mix of titanium white and light red. Reflections often need warming or cooling with another pigment, as they take their color from the color of the light source.

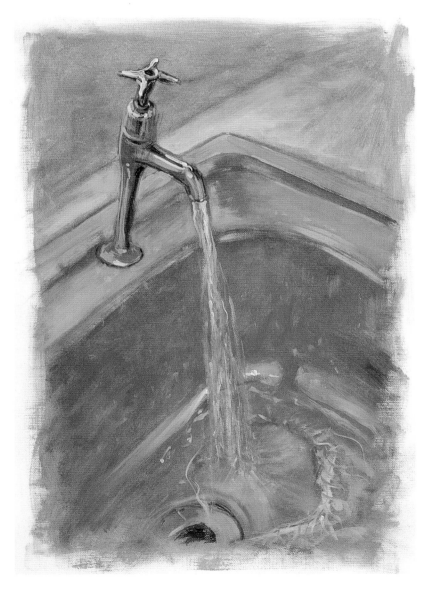

7 Finally, add some touches of titanium white to the faucet to complete the painting.

My waves look like cardboard cutouts. What am I doing wrong?

Waves are essentially architectural forms; but they are structures that are constantly changing as they crash down and become reconstructed. Observe the principal forms carefully; these include the outer contours of rolling banks of froth and spray, which are part of this architecture.

There can be a surprising number of deep colors in waves that contrast with the white of the spume. But lightness does dominate, and finding a range of pale tints to break up the blandness of white can be quite difficult. Paint the general outline of your waves first, including the crests of the waves and the patterns of the foam. Then, as you paint, closely observe the color and movement of the waves.

2 Paint the main body of the sea with phthalocyanine blue and green, lightened with varying amounts of titanium white. Leave the foam from the breakers and the choppy water white, with various tints of blue and green in the depressions.

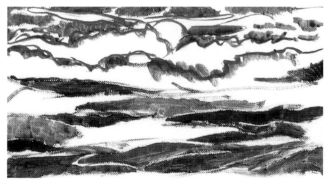

1 On a white surface, paint the outlines of the patterns created by the foam with phthalocyanine blue. Make sure the lines are not all parallel to the bottom edge of the picture; only the horizon is absolutely horizontal. The diagonals of the wave and the ripples give the painting dynamism.

3 The shallower sea in the immediate foreground is fragmented by areas of foam. Apply a transparent mix of red-violet and ultramarine so the white support glows through.

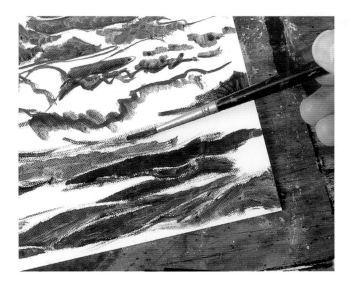

4 The foreground area is in shadow. Paint the depressions in the water and gently blend in slight shadow detail to the foam in the foreground with a mix of red-violet, ultramarine, and titanium white.

5 Paint the body of the wave behind the big breaker with a mix of ultramarine and a little red-violet. Lighten the color as it nears the foam, but keep it dark at the top. Lightly blend in some faint lilac lines where the wave curves to give it volume and a sense of power. Create a very pale lilac using the same colors as the foreground but with more titanium white. Use this mix to paint swirled patterns with your brush to give the foam texture.

ARTIST'S NOTE

To paint water successfully, it is necessary to simplify what you see, but you cannot hope to distil the essence of a subject until you are familiar with its complexities. Be prepared to spend time watching water; then, when you begin to paint, never attempt to paint every tiny detail of a ripple or wave. This will result in a fussy and weak painting. Trust your own observations and try to achieve strength through simplicity.

6 Paint the sky with a mix of ultramarine and titanium white. Apply the color evenly so that it acts as a powerful contrast to the cold brightness of the frothy sea. The vertical format of the picture gives the composition a monumental feel, making the viewer look up at the wave crashing in.

My waves look like cardboard cutouts. What am I doing wrong? **113**

Demonstration: **Lighthouse in heavy seas**

The sea is not easy to paint from life because it is constantly changing. Every passing cloud affects the light; the tide comes in or goes out; wind ruffles the ocean, changing its texture; and mist creeps up to mask a horizon that was clear and sharp only moments before.

In this painting, there is plenty of scope for experimenting with techniques such as spattering, dry brushing, scumbling, sgraffito, and glazing to capture the various moods and textures of the sea.

1 Use choppy brush strokes to apply a layer of titanium white mixed with impasto medium to the whole surface of the canvas. The textured brush strokes will show through when color is dragged over them later. Let this layer dry, and freely apply a layer of ultramarine thinned with turpentine and painting medium with a piece of sponge.

2 With a 1-inch (25-mm) house-painting brush, apply a mix of ultramarine, ivory black, and lemon yellow with painting medium, to depict the sea and suggest nearby waves. Place the horizon just below the middle of the picture.

3 Block in the sky with parallel, horizontal brush strokes, using a mix of cobalt blue, titanium white, and painting medium. Leave the underpainting showing through where you will later fill in the wave and lighthouse.

4 Use a large flat hog brush to lighten the sea in places with an ultramarine and titanium white mix. The texture of the white underpainting should show through the brush strokes.

5 Do not paint the outline of the lighthouse, but start by painting its top using a small flat sable and a mix of painting medium and ivory black.

Demonstration: Lighthouse in heavy seas **115**

6 For the finest details use a very small round sable brush with a good point. The ivory black mixes with the sky color as you paint, giving some delicate light and shade.

7 Now use a flat sable again and titanium white to add more light touches to the metal frame and windows.

8 Add a little emerald green on the windows and some cadmium red deep on the top of the lighthouse. With a larger, long flat hog, drag some titanium white across the lighthouse base. Apply lighter pressure to the side where the wave crashes against it so that less of it is visible. This will make the lighthouse look rounded.

9 Dab on ivory black with the tip of a flat hog to paint the lighthouse name.

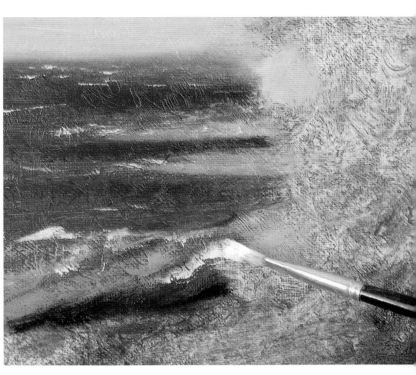

10 Create the shadows on the sea with ivory black, and apply a patch of sky color next to the dark side of the lighthouse to make it stand out.

11 Use titanium white and the edge of a long, flat hog brush to touch in the distant white tops of the waves. Increase the size of the strokes in the foreground. The very small marks in the distance contribute to a sense of distance.

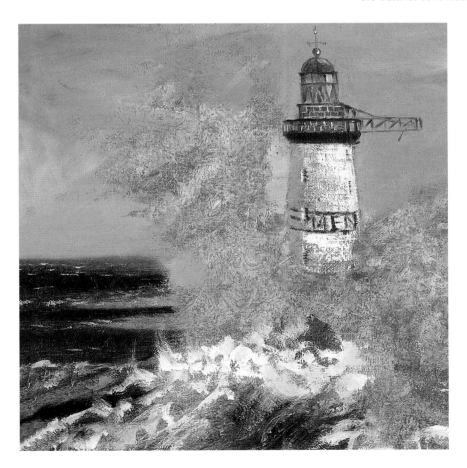

12 Apply more titanium white to the waves in the foreground, using free and spontaneous brush strokes to give a sense of movement and power.

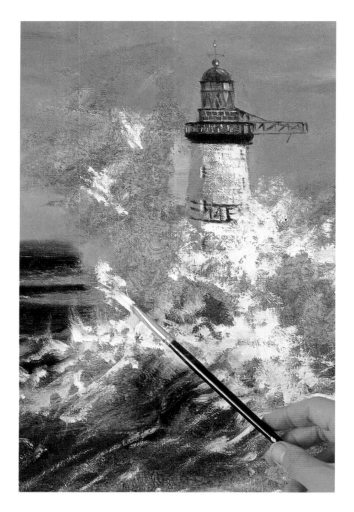

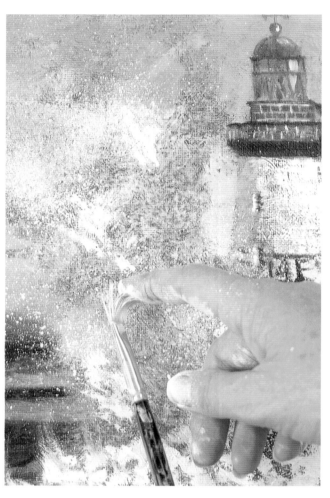

13 Add a touch of lemon yellow to the white to convey an impression of late afternoon sunlight. Dab and drag the color to suggest plumes of spray.

14 Use a flat hog brush to spatter a mist of tiny droplets for the fine clouds of spray sent up by the breaking wave.

15 When spattering, the paint must be quite thin, so add extra turpentine and medium to the mix. Hold the brush close to the canvas to avoid spraying too far across the picture.

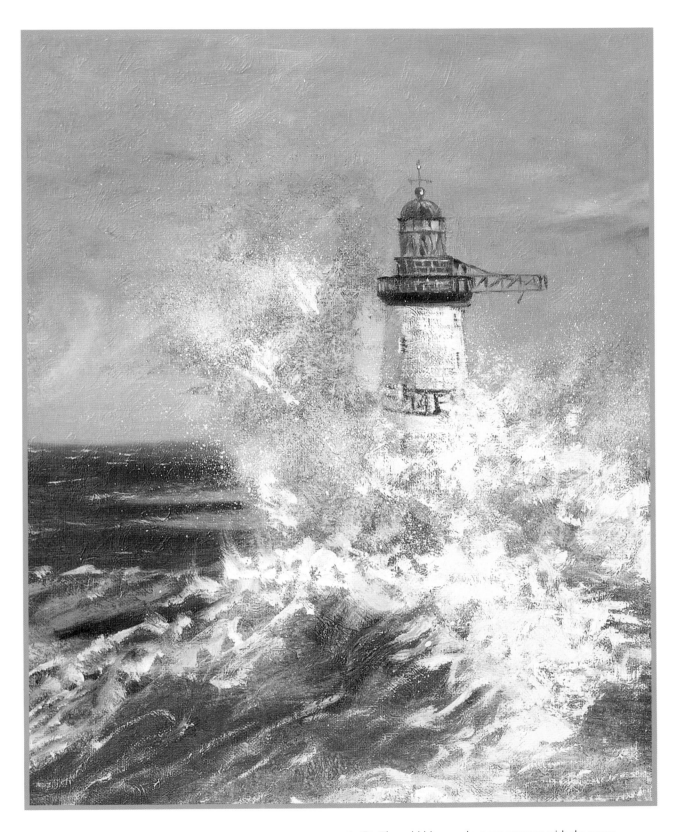

16 The cold blues and greens contrast with the warm evening light catching the spray. Light, fast, and sensitive brush strokes help convey the sea's fluidity. The free handling of the waves contrasted with the delicate treatment of the lighthouse make it look almost fragile.

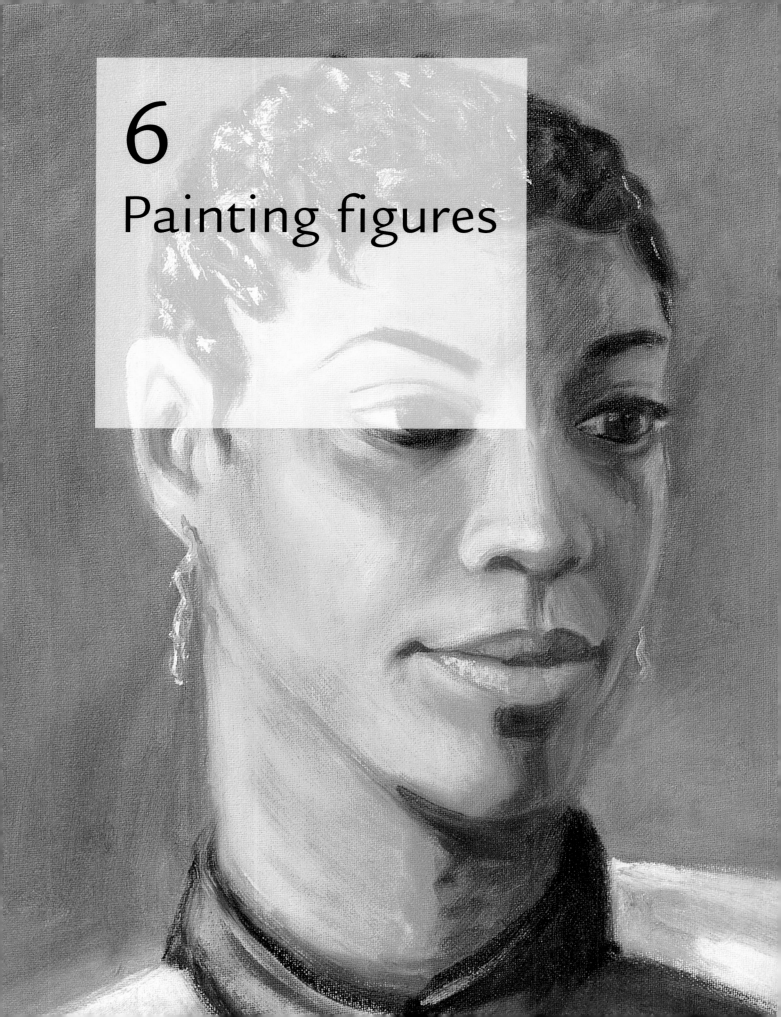

6
Painting figures

There is nothing as fascinating as painting another human being, and nothing quite as challenging. Again, observation is the key to success with portraiture—with technique coming a close second.

When you have persuaded someone to sit for you and are about to begin painting, remember that however you might be feeling, it is up to you to put your sitter at ease. Choose a pose that is easy for the model to hold, and make sure that their chair is comfortable. The more comfortable the sitter is, the longer the person will be able to sit before needing a break.

A solitary figure will always be the main focus of a painting, even if indistinct and in the middle distance. If you paint a full-length figure, the face will be the focus; if you paint the head and face only, the eyes will be the focus, just as when we meet people in real life. Therefore, the direction of the gaze in portraiture is vital.

Figures can appear in pictures for many reasons. They may be included in the distance to give scale to a landscape or street scene; they may be in the middle distance, grouped to lead the eye into the picture, or to give interest to a setting; or they may be the main subjects. Their function in the painting will dictate the way you paint them. Groups of figures need to be integrated into the space and handled in the same way as every other element in the picture.

Take a sketchbook to a crowded railway station, airport lounge or bar, and fill it with studies. Then try some paintings from the best studies. Don't let your brushwork become fussy; stick to essentials. It may help to use a larger brush than you think you need; that way you will be *forced* to simplify. Working from photographs is good practice too, and it allows you to make a more finished painting. But don't become discouraged; painting portraits doesn't always come easily, and it takes even the best artists years of practice. The pleasure is in following the process; then painting portraits can be an endless source of enjoyment.

I have trouble painting features when my subject's head is turned. Do you have any advice?

The angle that gives the most difficulty is the three-quarter view, when your sitter's head is not looking straight at you but is turned by 45 degrees. The features are then distorted, or foreshortened. It seems we all have an unconscious mechanism that tries to turn a head back to look the viewer straight in the eyes, perhaps because, being symmetrical, a head is much easier to draw that way. However, when we view a head in perspective, the two viewpoints—one observable, the other imagined—become muddled, and this is why the head does not look convincing. Although the contour of the head may be correctly observed for a three-quarter view, the features are probably placed too much in the center of the space designated for the face. In a correctly drawn three-quarter view of a head, the center line of the face is closer to the side of the head that is turned away from you.

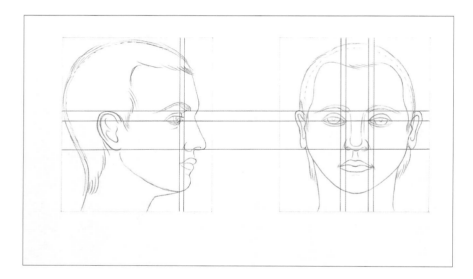

When drawing, bear in mind some facts about the general proportions of the head and the alignment of features. In this diagram, you can see that the eyes should be approximately halfway down the head. The ears should line up with the eyes and nose, and the pupils of the eyes should align with the corners of the mouth. The inside edges of the eyebrows line up with the corners of the eyes, and the space between the bottom of the nose and the chin is greater than that between the bottom of the nose and eyes.

The next thing to observe is what happens to the head when it is at an angle. Note in this diagram that, as the head moves, the proportions change because it is seen in perspective. Looking down has the effect of compressing the features, and more of the top of the head is visible. Looking up reduces the apparent size of the top of the head. When a person is looking to one side, you see more of the back of the head and less of the features.

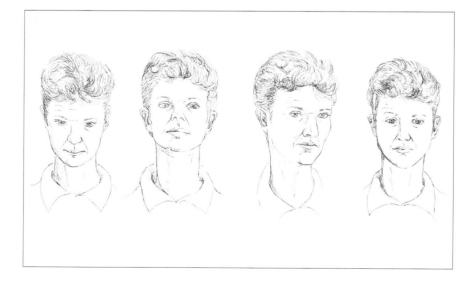

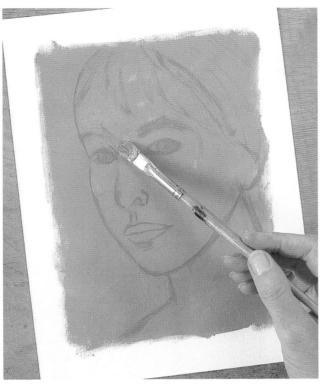

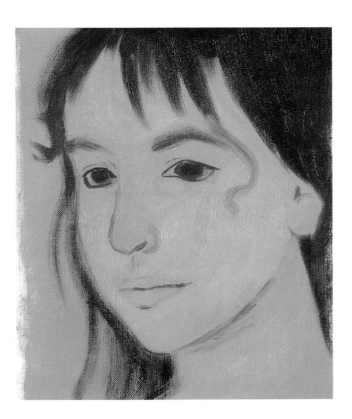

1 Draw this woman's head using a mixture of yellow ochre, cadmium red, and a little titanium white. A good drawing as a starting point makes painting much easier. It is a good idea to practice *drawing* heads before painting them.

2 The right eye is in steep perspective, as is the far side of the mouth, so place the nose well over to the left. Notice how narrow the gap is between the tip of her nose and the contour of her right cheek and how wide the space is between her left nostril and ear. Also, the two eyes are not the same size or shape.

Left An important point to remember is that no single plane of the head is flat, especially the curving surface of the face. Before you start to paint, draw a light sketch and place guidelines around the head so that you can position the features on the curving surfaces. Draw an imaginary line down the middle of the face to help you line up the features. Then, following the guidelines, gradually add the modeling and details of the features.

I have trouble painting features when my figure's head is turned. Do you have any advice?

How can I paint the facial features so they are integrated with the rest of the face?

The important thing to remember when painting features is their shape and their relationship to the head as a whole. Eyes are often painted with too much prominence and are usually simplified into flat oval shapes with a circle in the middle for the iris. Instead, the eye should be drawn in relation to the rest of the face, taking into consideration the eyelids, eye sockets, and brows. Noses, on the other hand, are often caricatured, giving little sense of shape or form. To avoid this mistake, define the bottom of the nose carefully, and measure its distance from the ears and mouth accurately. Similarly, mouths are often painted as flat forms when in fact a mouth is a soft, full shape with depth and detail. As with the other features, it is important to relate lips to the surrounding forms. By considering each feature separately, we can observe the specific problems of each and see how we might better draw and paint them.

In this straight-ahead view, the top lid partially covers the iris, but a little white is visible above the bottom lid.

As the eye turns upward, much more of the white is visible, and the size of the top lid decreases.

With the eye almost closed, the top lid follows the curve of the eyeball.

In this three-quarter view, the eye is seen in perspective and thus changes shape. Notice that much more white is visible.

In a side view, the curvature of the eyeball is very apparent.

With the head turned away, more of the lid and eyelashes are visible.

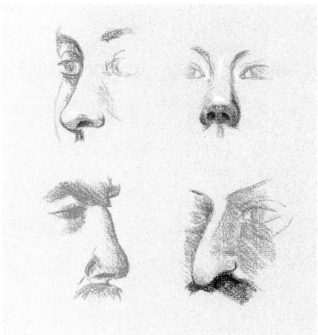

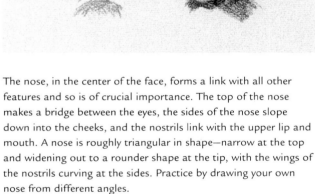

The nose, in the center of the face, forms a link with all other features and so is of crucial importance. The top of the nose makes a bridge between the eyes, the sides of the nose slope down into the cheeks, and the nostrils link with the upper lip and mouth. A nose is roughly triangular in shape—narrow at the top and widening out to a rounder shape at the tip, with the wings of the nostrils curving at the sides. Practice by drawing your own nose from different angles.

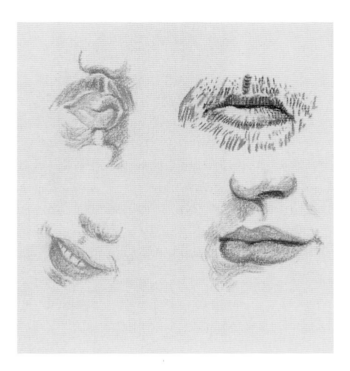

Mouths are a particularly important feature in portraiture because they are responsible for a great deal of the expression of the face. Lips follow the shape of the jaws and of the teeth behind them. The sides of the mouth are two planes, which have their high point at the "Cupid's bow" in the center of the mouth and then curve gently into the cheek. This curve is the reason for the steep recession at the far side of the mouth seen in a three-quarter view.

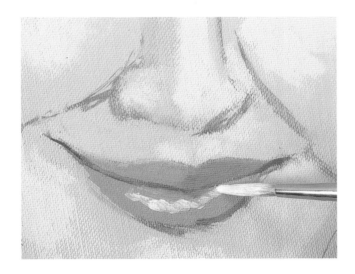

When painting a smile, the corners of the mouth, the mouth opening, and the contour of the lower lip should all be delicately painted. Do not overemphasize any element or you could turn the smile into a grimace.

Facial expressions are controlled by muscles, many of which are interconnected, so when we laugh, we do so with our whole face. It is a good idea to practice drawing facial expressions in your sketchbook before attempting to paint a whole portrait.

How do I achieve realistic skin tones?

The color of skin varies enormously, even within specific racial groups. The tints and shades you see will of course also depend on lighting conditions. Skin is reflective, so any colors nearby will influence the colors you see. Think of your choice for flesh tints in two ways; first, as relatively lighter or darker than one another (tonal); and second, as relatively warmer or cooler (chromatic). Develop your ability to see chromatically as well as tonally.

The side of a face in shadow is the most difficult to interpret chromatically, even though it is easy to see differences in tone. Look for the unexpected tendencies toward green, purple, blue, and red, and then experiment with trying to mix that color in different ways. Try to avoid making the half-tone too brown or too gray. Also, highlights tend to be tinted with the color of the light source; if that is cool, highlights will be bluish, and if warm, yellowish. As you mix your flesh tints, test them on a scrap piece of paper before you apply them to your portrait.

The trick to painting skin tones is to begin by establishing the overall color of the person's face. You can then build upon this base with other colors as you add shading and highlights. The mix used in this example is yellow ochre, cadmium red, and titanium white.

ARTIST'S NOTE

Even within the same racial group, face colors vary enormously; "white" skins can be pinkish, olivey, creamy, or quite dark brown or red if the person has spent a lot of time outdoors. You can improve your color assessment by squinting your eyes. This blurs the features and any other details and gives you a broad impression of both the color and the tone of the skin.

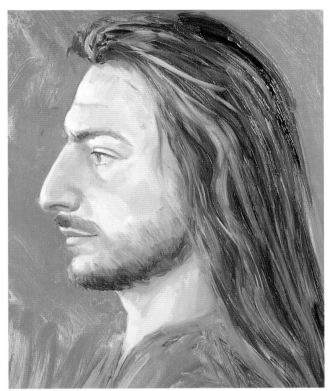

For this portrait, the initial flesh tint is a mix of cadmium orange, cobalt green, Indian red, and white. The lighter highlights on the cheek bone and nose are cobalt green and white, with the addition of cerulean blue.

In this portrait, the skin is painted with a mix of raw umber, cadmium orange, and Venetian red. This tone is cooled in places with cerulean blue.

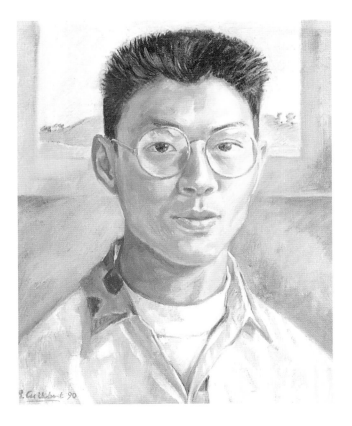

The base color for this portrait is yellow ochre and raw sienna, with some titanium white and a little lemon yellow. The shadow area is a mix of cobalt blue and cadmium red.

 # Demonstration: **Portrait**

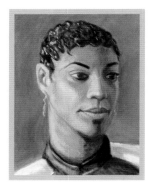

It is difficult to paint an exact likeness of a person, but the key is to closely observe the geometry of a face and understand its individuality. Like any skill, this is something that can be cultivated through practice. And, as with all technically difficult subjects, it is a good idea to gain practice and insight through drawing before trying to achieve anything with paint.

Capturing the exact spacing between the eyes, ears, nose, and mouth is essential when it comes to realizing a likeness. Achieving the right skin tones is another important aspect. In this portrait, an overall flesh tone is painted first, and shading and light are added later with blues, greens, and yellows.

1 Paint the outline of the head with a large round hog brush and yellow ochre thinned with turpentine. This is a three-quarter portrait, so pay attention to the foreshortening of the features, and make sure the nose is positioned correctly.

2 Block in the background color first, and then the face, with yellow ochre thinned with turpentine and painting medium. Keep the paint thin at this early stage, so you don't obscure the drawing.

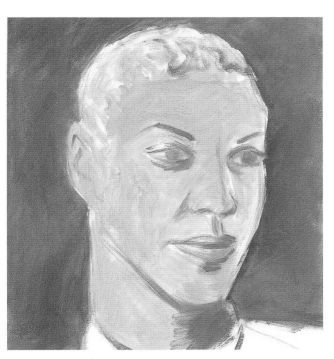

3 Use the round hog brush to strengthen the drawing with a mix of burnt sienna and a little monestial blue. Don't simply go over what you have already done; reassess your drawing, and make corrections where necessary.

4 At this stage, the drawing should already bear a likeness to the sitter. If it doesn't, scrutinize your model and adjust the drawing to improve the likeness until you are happy with it.

5 This model has very short hair that is sculpted into stiff waves. Use a round hog brush to apply an underpainting of burnt sienna for the hair.

6 With the same color, begin to block in the shadowed side of the face. This will establish the light and shade in the portrait with warm tones, which will help with the development of the flesh tints.

7 The surrounding blue walls reflect color onto the sitter's face, which seems to create a central panel of color. Add a mix of monestial blue and a little burnt sienna where you can see hints of blue on the face. Also add it to the hair, as you make it gradually darker.

8 Use the mix of burnt sienna and a little monestial blue, brushed on thinly, to develop the modeling of the face. Make your brush strokes follow the direction of the curves of the face.

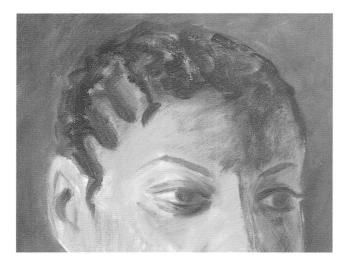

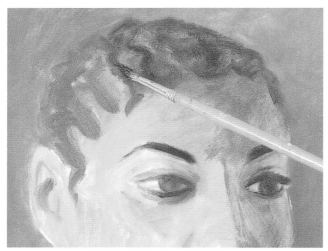

9 Apply a layer of ivory black to the model's hair. Allow the underlying layers of color to show through where the scalp is partly visible. Then use the same color to darken the eyes.

10 At this stage, the head has taken shape and the likeness is apparent, but the brush strokes still look fairly crude.

11 Returning to the lit side of the model's face, use a bright flesh tint of yellow ochre, cadmium yellow, and some titanium white to smooth the rough underpainting. Apply a generous layer, and develop the light from the temple to the neck.

12 Next, use a mix of burnt sienna, cadmium orange, and titanium white to warm the shadowed side of the face. Blend this color into the preceding ones.

14 The modeling of the bones and flesh is now almost complete. There are only a few more details needed to bring the portrait to life.

13 Use the same color to paint the other side of the sitter's nose, around the left eye socket and the forehead.

15 Add highlights with a mix of lemon yellow and white. Lemon yellow is a cold yellow, so the highlights will be slightly cooler and paler than the surrounding flesh tints.

16 Use a medium round nylon brush to paint around the top of the model's upper lip with a mix of burnt sienna and a little monestial blue.

17 The far edge of the dark side of the face reflects a little light, so paint it with a mix of burnt sienna and white. Take care in mixing this subtle color that it does not jump out at the viewer, then use burnt sienna to paint the warm brown of the eyes and add a touch of white with the tip of your brush for the highlights.

18 For the final touch, add some shine to the sitter's sculpted hair using a mix of indanthrene blue, burnt sienna, and titanium white. Apply this with a rolling movement of the brush.

19 No painted portrait will capture a photographic likeness of a sitter, but this should not be your goal. Close observation and a gradual buildup of color will reward the portrait painter and the viewer by capturing some of the sitter's personality.

How can I improve my paintings of hands?

Hands are difficult to draw because they can assume so many different positions and always present surprising shapes. Until you have had plenty of practice at drawing them, your paintings of hands are likely to appear amateurish. First, observe the shape and the proportions of a hand. A hand is broader and flatter than a wrist, and a palm is basically square. The thumb has a low connection toward the wrist, and the fingers are jointed by three rows of knuckles—the first along the top of the palm. The distance between knuckles gets progressively shorter toward the fingertips and fingers taper toward their tips.

Draw a hand first as an overall shape. Arrange the knuckles in steepening curves toward the fingertips, as the finger bones shorten between each joint.

1 Observing the shape and proportions of the hand, sketch in pencil. Then paint the surrounding blue of the jeans with varying mixes of blue and titanium white. Next, apply a green underpainting to the hand with a mix of titanium white and Hooker's green. This will disappear as the painting progresses, but it will continue to have an effect on the colors as it shows through the layers.

2 Add a half-tone with a mix of the green underpainting and yellow ochre, cadmium red, titanium white, and blue.

3 Next, create a pale flesh tint using all the colors from the previous mix but without the blue and with a touch more titanium white. Use a medium filbert sable to paint across the back of the hand and along the wrist, gently blending the color into the preceding layers. Leave darker areas unpainted where you want to create shadows between the fingers and the shaded side of the hand.

4 Add some red ochre to the mix to create a warmer, deeper color for extra shading. This will counteract with the green underpainting, which is still too dominant. Use the edge of your brush to define the details around the fingernails.

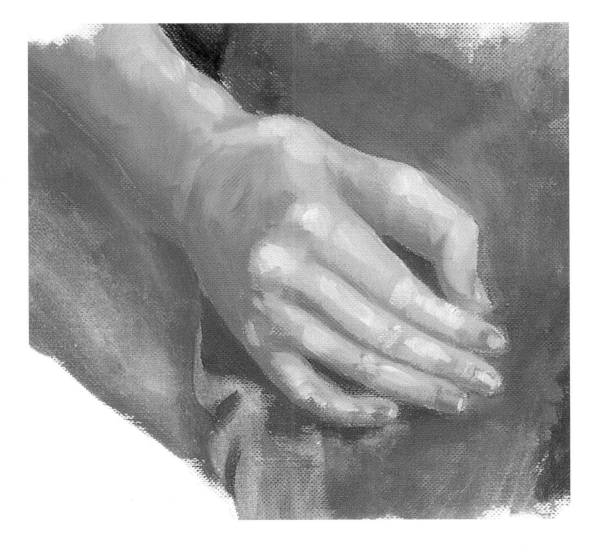

5 Finally, add some highlights with a mix of titanium white and small amounts of yellow ochre and blue.

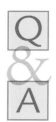

How do I paint movement convincingly?

Contours and detail convey solidity and stillness. But plenty of paint and swift brushwork will impart a sense of movement. The degree of the form that should be developed depends on the extent of movement; the faster the movement, the less the contour is needed. When the contours are interrupted with fast strokes of the brush, the painting dissolves into movement. Blurring and merging the colors of the subject with your brush adds to the effect.

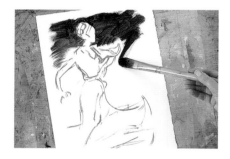

1 First, sketch the general form of the dancer with alizarin crimson. Then mix the crimson with viridian to create a rich, dark shade for the background.

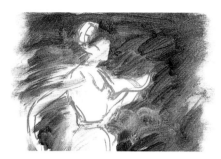

2 Paint the background freely, brushing across the contours of the dancer in places. Establish a sense of movement from the start.

3 Next, apply an underpainting of cadmium orange, titanium white, and alizarin crimson to the dancer and her swirling costume.

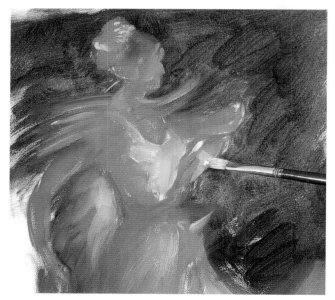

5 Apply cadmium yellow to brighten areas of the dancer's dress. Apply this roughly to the back of her dress and around her neck area to enhance the twisting movement of her hips.

4 In places, blend the red into the surrounding darks, using broad, sweeping brush strokes to imitate the dancer's gyrations.

6 With a mix of cadmium yellow and titanium white, suggest a warm flesh tint on the dancer's face and arm. Darken the background further by adding ivory black to the viridian and alizarin crimson. This brings the dancer forward from the rest of the painting and strengthens the movement of her body and dress.

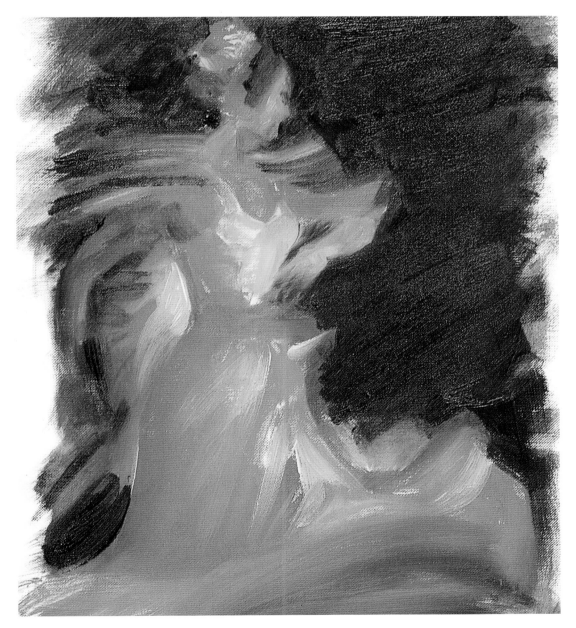

7 Do not add too much detail to the painting. Everything should be left undefined to capture the sense of movement.

D Demonstration: **Picnic by a river**

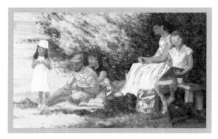

Groups of figures are wonderful subjects for a painting, and they have provided artists with inspiration for centuries. Figures can tell stories about their relationships, their histories, and their predicaments, so artists have often grouped figures together to tell epic tales, depict religious stories, and record political events.

A group figure painting is quite a challenge to organize and paint convincingly. A photograph is often useful as a starting point, but the composition may need to be altered to make a good painting. The painting below is taken from a photograph of a group of people having a picnic in a field. The composition is an ideal balance of the positions and relationships of the different figures.

1 The photograph shows a classical grouping of figures. The mother and child on the right appear light against a dark background, and on the left, the figures melt into the light. Divide the photograph into a grid of squares before you start to draw.

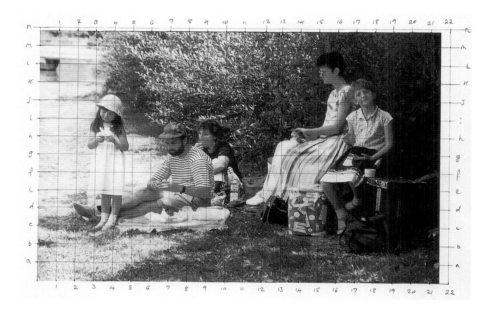

2 Transfer the grid onto the support, and copy the photograph so that the size and positions of the people are accurate. This is a particularly good way to work if you do not feel confident about your drawing.

3 Apply the base colors first. Paint the grass with a mix of lemon yellow, titanium white, and painting medium.

4 Use a rigger brush to underpaint the figures with yellow ochre.

5 For the bushes in shadow, apply an underpainting of permanent mauve. Work carefully round the figures so that you don't obscure the drawing. Using a pair of complementary colors for the underpainting gives the piece interest.

6 Apply an ultramarine underpainting for the bushes and the clothing. Scumble it over the bushes to deepen the shadows.

7 For white surfaces like the girl's dress, apply a coat of titanium white. Don't leave the primer showing in such areas, as this will make the painting seem patchy.

8 Next, darken the figures with a mix of cadmium scarlet and yellow ochre. Develop the figures together to ensure that they are integrated into the picture.

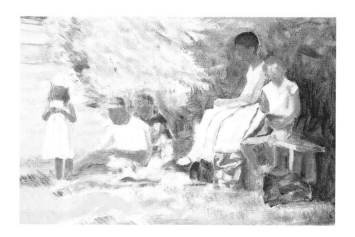

9 At this stage, the composition is roughly mapped out, but the paint is very thin. A thicker coat is needed to mask the grid of the initial drawing.

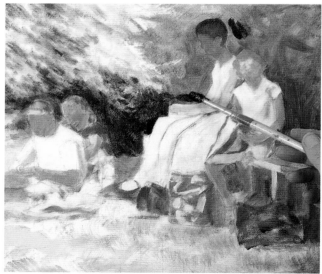

10 Use short, broken brush strokes to paint the hedge with viridian, a transparent green. Here, the underpainting shows through, altering the hue.

11 Now you can see that the dark green creates a dramatic contrast between the light and the shade.

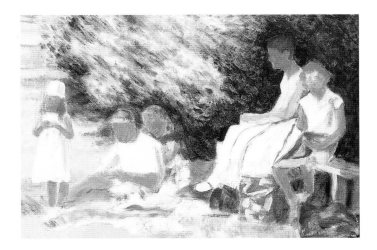

12 For the grass in shadow, mix cadmium lemon and emerald green. Use this color for the bushes as well.

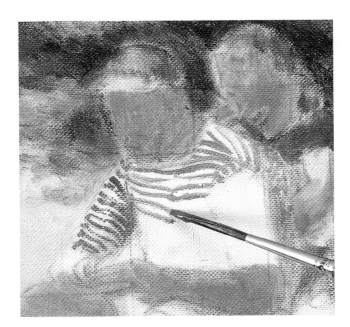

13 Begin to add details with a rigger brush, painting the red stripes of the man's T-shirt with cadmium red.

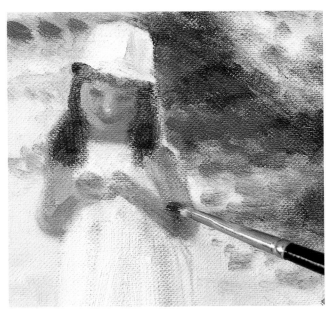

14 Paint the standing girl's hair and some shading on her arm with permanent mauve. Use the same color for shading the features of the other people in the painting.

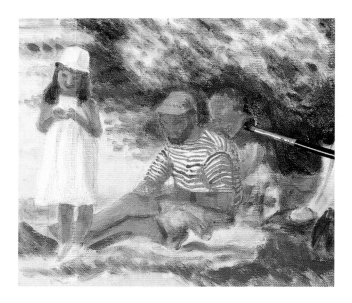

15 Use a fine flat sable brush to paint the woman's hair and blouse with a mixture of ultramarine and permanent mauve.

16 Apply small dabs of paint and don't make the painting too detailed. This helps keep the picture unified even though the composition is fairly complicated.

17 The finished painting is a colorful but balanced compostion that successfully captures the warm atmosphere of a lazy afternoon picnic.

Index

A

alla prima 8, 20-1
atmosphere 47, 75, 78, 92
Auerbach, Frank 6

B

Boudin 106
brickwork 12, 92, 93
brushes 11, 12-13, 18, 19, 38, 40-4,
 56-7, 84-5, 86-7, 114-18
buildings 19, 75, 92, 94-9

C

canvas, stretching 14
Cézanne, Paul 27
charcoal 18, 36, 94
Chardin 47
cloth 68-73
 folds in 61-3, 71
 patterned 62-3
clouds 17, 32, 40, 80-1, 95, 106
color
 blending 32-3, 65, 84, 91
 blocking in 52-3, 61, 62, 80, 82, 87,
 94, 95, 96, 102, 115, 128, 139
 mixing 27-45, 54, 55
 theory, understanding 27-45
 wheel 28, 31
colors
 complementary 8, 27, 29, 59
 primary 9, 27, 28
 secondary 9, 27, 28
 tertiary 27, 30-1, 59
composition 46-73, 138-42
contrast(s) 34, 35, 51, 76
chromatic 34
 tonal 34, 84

D

Degas 138
demonstrations 40-5, 68-73, 86-91,
 94-9, 106-9, 114-19, 128-33, 138-42
detail 47, 52, 53, 54-9, 66, 75, 76, 77,
 82-3, 92, 94, 95, 97, 98, 116, 124,
 137, 142
dilutents
 linseed oil 11, 15, 17, 27, 36, 37
 turpentine 11, 15, 16, 17, 18, 23, 27,
 36, 37, 52, 54, 62, 86, 87, 114,
 118, 128
diluting 27
drawing 20, 24, 37, 40, 48, 50, 52, 56,
 60, 61, 62, 64, 68, 94, 102, 106, 110,
 123, 124, 125, 128, 134, 138 *see
 also* sketching
Ducasse, Isidore 47
Dyce, William 106

E

equipment 6-7, 11
 outdoors, for painting 86

F

fabric *see* cloth
figure, human 106, 120-42 *see also*
 portraiture
 groups 121, 138-42
 hands 134-5
 movement 136-7
fingers, using 11, 16, 17
fixative 8, 18
flowers 54-9
fog 84-5 *see also* mist
folds *see* cloth
foliage 16, 82-3, 88, 89, 98
formats
 landscape (panoramic), portrait
 (vertical), square 48, 86, 113
Freud, Lucian 6

G

gel medium 62, 139
glass 61, 66-7, 70, 72, 92
glazes, glazing 8, 22, 23, 27, 36-9, 45, 114
 making 36, 37
gradation 8, 52
grass 42, 43, 90
grounds 40, 104, 110
 background 34-5, 56, 58, 60, 63, 65,
 66, 68, 75, 76-7, 78, 90, 136, 137
 foreground 42, 43, 75, 76-7, 78, 79,
 88, 106, 113, 117
 middle ground 75, 76-7, 78, 90

H

highlights 8, 51, 52, 60, 61, 62, 63, 64,
 66-7, 71, 72, 73, 77, 94, 98, 110, 126,
 127, 132, 135
hills 40-5, 76-7, 78, 79
hue 8, 27

I

impasto 8, 19, 40, 44, 57, 88, 90,
 114
impressionists 138

L

landscapes 29, 40-5
 and townscapes 74-99
lean to fat 15, 36
leaves 59, 84 *see also* foliage
light 20, 27, 47, 50-1, 56, 57, 63, 66-7,
 71, 78, 85, 92, 95, 96, 98, 104, 105,
 107, 110, 111, 116, 119, 129, 132,
 141
lighting 50, 61, 126
linseed oil *see* dilutents
Lowry, L.S. 101

M

mahl stick 8, 106, 108
metal 64-5, 68-73, 110, 116
mist 17, 32, 85 *see also* fog
mistakes, correcting 11, 18, 22-3,
 24
Monet 6, 20, 40
Morandi, Giorgio 47
movement, painting 136-7

N

negative space(s) 8, 49, 77, 80

O

outdoors, painting 86-91

P

painting medium 15, 36, 37, 39, 40, 61,
 68, 86, 87, 94, 102, 104, 110, 114,
 115, 118, 128
palette, starter 27
pencil 11, 18, 64, 82, 92, 134
perspective 8, 25, 60, 92, 94, 96, 122,
 124
 aerial 8, 75, 78-9
 atmospheric 45
 linear 8, 25
 one-point 8, 25
 painting circular objects in 60
 three-point 25, 75
 two-point 25
Picasso 6, 106
pigments, transparent 38
Pissarro 20
portraiture 121-33 *see also* figure, human
 face, features 122-5
 head, perspective 122-3
 skin tones 126-7, 128

R
Raphael 101
reflection(s) 61, 64–7, 68–73, 92, 101,
104–5, 108, 109, 111, 130
resists 9

S
scumble, scumbling 9, 81, 91, 95, 97, 99,
114, 139
sea 17, 39, 101, 106–9, 114–19
waves 112–13, 114–19
sgraffito 9, 16, 53, 114
shading, shadows 21, 27, 37, 43, 47, 48,
50–1, 52, 53, 54, 56, 57, 60, 61, 62,
63, 65, 68–73, 77, 80, 92, 93, 94, 95,
96, 113, 116, 117, 126, 129, 135, 141
sketchbook 11, 86, 121, 125
sketch, sketching 18, 36, 54, 61, 82,
87, 91, 92, 104, 123, 134, 136 *see
also* drawing
sky 16, 39, 40, 76, 80, 84, 88, 95, 99,
102, 106, 113, 115, 116, 117
spattering 9, 16, 17, 99, 114, 118
sponge, sponging 9, 11, 16, 56, 114
still life 33, 46–73
stipple, stippling 9, 42, 57, 59, 72, 80
sun, sunlight 81, 84, 85, 87, 96, 98, 103,
104, 118
sunset 32, 76

T
technique 11–25, 54, 121
texture 9, 12, 17, 19, 21, 38, 40–5, 47,
59, 80, 97, 99, 113, 114, 115
Thiebaud, Wayne 6, 47
tint 9
Titian 6
tone 9, 27
Tonking 9, 24,
trees 19, 40, 41, 44, 45, 77, 82–3, 84–5,
89–91, 94, 95, 97, 99
turpentine *see* dilutents

V
Van Eyck, Jan 6
Van Gogh 20, 47
vanishing point 9, 25
varnish 36
viewfinder 9, 48, 75, 86

W
water 19, 100–19
painting reflections on 104–5
waves *see* sea
wet into wet 9, 20, 21, 57, 69, 70
windows 92–3
wood 12

Picture credits

Page 25, bottom, John Newberry

Page 41, bottom, Ronald Jesty

Page 61, bottom, Arthur Maderson

Page 77, Lucy Willis

Page 81, Moira Clinch

Page 83, top, Thomas Girtin

Page 83, bottom, David Bellamy

Page 91, Moira Clinch

Page 99, top, Milton Avery

Page 99, bottom, Margaret M Martin

All other artworks by the author